FEDERICO ZERI (Rome, 1921-1998), eminent art historian and critic, was vice-president of the National Council for Cultural and Environmental Treasures from 1993. Member of the Académie des Beaux-Arts in Paris, he was decorated with the Legion of Honor by the French government. Author of numerous artistic and literary publications; among the most well-known: *Pittura e controriforma*, the Catalogue of Italian Painters in the Metropolitan Museum of New York and the Walters Gallery of Baltimore, and the book *Confesso che ho sbagliato*.

Work edited by FEDERICO ZERI

Text
based on the interviews between
FEDERICO ZERI and MARCO DOLCETTA

This edition is published for North America in 1999 by NDE Publishing*

Chief Editor of 1999 English Language Edition
ELENA MAZOUR (*NDE Publishing**)

English Translation
MARK EATON FOR SCRIPTUM S.R.L.

Realisation
CONFUSIONE S.R.L., ROME

Editing
ISABELLA POMPEI

Desktop Publishing
SIMONA FERRI, KATHARINA GASTERSTADT

ISBN 1-55321-004-2

Illustration references

Bridgeman/Alinari archives: 10tr, 11, 12b, 19t, 30, 37t, 39tl, 44/IV, 45/III-XII.

Dufoto: 40t, 41cl.

Giraudon/Alinari archives: 1, 2-3, 4, 4-5, 6, 7, 8-9, 10c, 13t, 21t.

Luisa Ricciarini Agency: 25, 26, 44/X.

RCS Libri Archives: 2b, 15, 16b, 19b, 21, 22, 23t-b, 24b, 28t-b, 29, 31, 32-33, 34t-b, 36t, 39r, 41t, 44/I-II-III-V-VI-IX, 45/I-VII-IX-XI-XIII-XIV.

R.D.: 2t, 10tl-b, 12tl-tr, 13b, 14t-b, 16t, 17, 18, 20 t-b-c, 24t, 27, 33t-b, 35, 36b, 37b, 38, 39bl, 40c-b, 41cr-b, 42t-b-c, 43, 44/VII-VIII-XI-XII, 45/II-IV-V-VI-VIII.

67Pose: 45/X.

Printed and bound by Poligrafici Calderara S.p.A., Bologna, Italy

* *a registred business style of NDE Canada Corp.*
 18-30 Wertheim Court, Richmond Hill, Ontario
 L4B 1B9 Canada, tel. (905) 731-12 88

The captions of the paintings contained in this volume include, beyond just the title of the work, the dating and location. In the cases where this data is missing, we are dealing with works of uncertain dating, or whose current whereabouts are not known. The titles of the works of the artist to whom this volume is dedicated are in blue and those of other artists are in red.

DALÍ

THE PERSISTENCE OF MEMORY

The painting, of great evocative power, is one of Dalí's masterpieces. In an allusive and symbolic way, the painter indicates the active, conscious memory through the pocket watch and the ants that move about on it, and the un-

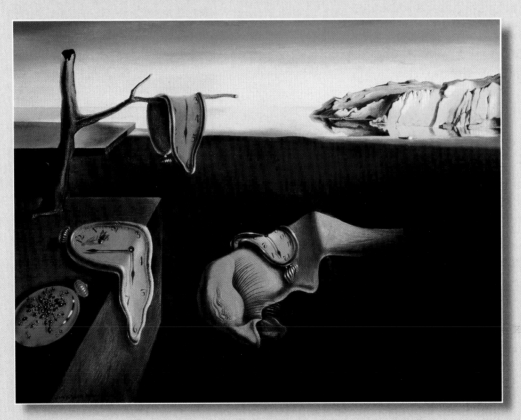

conscious memory through the limpness of the watches, which show no exact time. THE PERSISTENCE OF MEMORY thus describes the mnestic oscillations between the highs and lows of wakefulness and sleep.

AN IMAGINARY WORLD

THE PERSISTENCE OF MEMORY
1931

● New York, Metropolitan Museum of Modern Art (oil on canvas, 25 x 35 cm.)

● Salvador Dalí painted *The Persistence of Memory* during the period of Surrealism, which he joined in 1929 through his friends Garcia Lorca and Luis Buñuel. The Surrealists came together in 1924 in Paris around the poet and physician Breton, the soul of the group. The movement brought the age of avant-garde groups to a close, and used paradox as an instrument for radical criticism of bourgeois society, which in the political sphere had chosen Communism to fight its battles. In its depiction between the wars of a world of distorted forms, the movement took up the ideas of de Chirico, who had shown how reality is ultimately enigmatic and unknowable. The intellectual adventure of Surrealism was joined, among others, by the painters Miró and Ernst, the poet Eluard, the writer and director Artaud, the director Buñuel, and the photographer Man Ray.

● The main point of reference for the movement was Sigmund Freud, the father of psychoanalysis, who revealed the existence of the unconscious and explained how human actions are provoked by the impulses of the libido, the sex drive, which prevails over the conscious will. The Surrealists aimed to bring out the reality of the psyche by means of techniques that free it from the control of rationality, like the free verbal associations of *automatic writing* or *frottage*, a method of drawing based on tracing.

● Dalí, an anarchic though apolitical spirit, turned his painting into a projection of the unconscious. In *The Persistence of Memory* he suspends the landscape in a disturbing metaphysical limbo in which realistic and visionary elements are linked, as in delirium or dream.

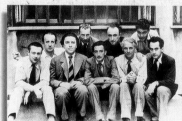

◆ THE SURREALIST GROUP
Paris, around 1930. Dali can be seen in the front row, between Breton and Ernst. Eluard is second left.

◆ SALVADOR DALÍ
The Catalan painter was born in 1904 in Figueras, where he died in 1989. His father, a notary, was a leading figure n the life of the town.

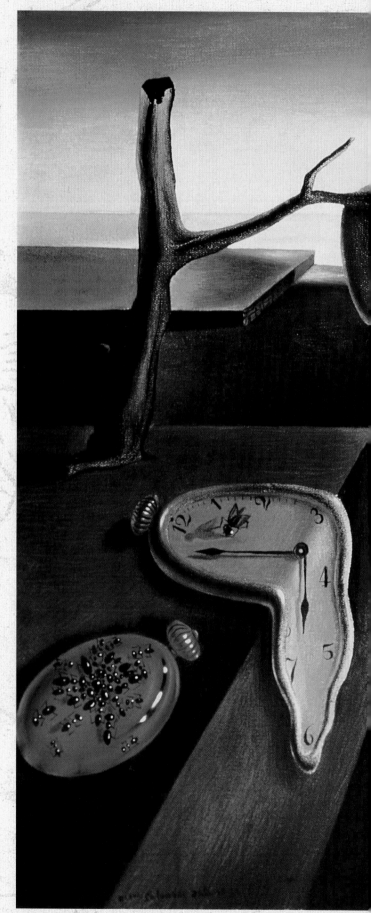

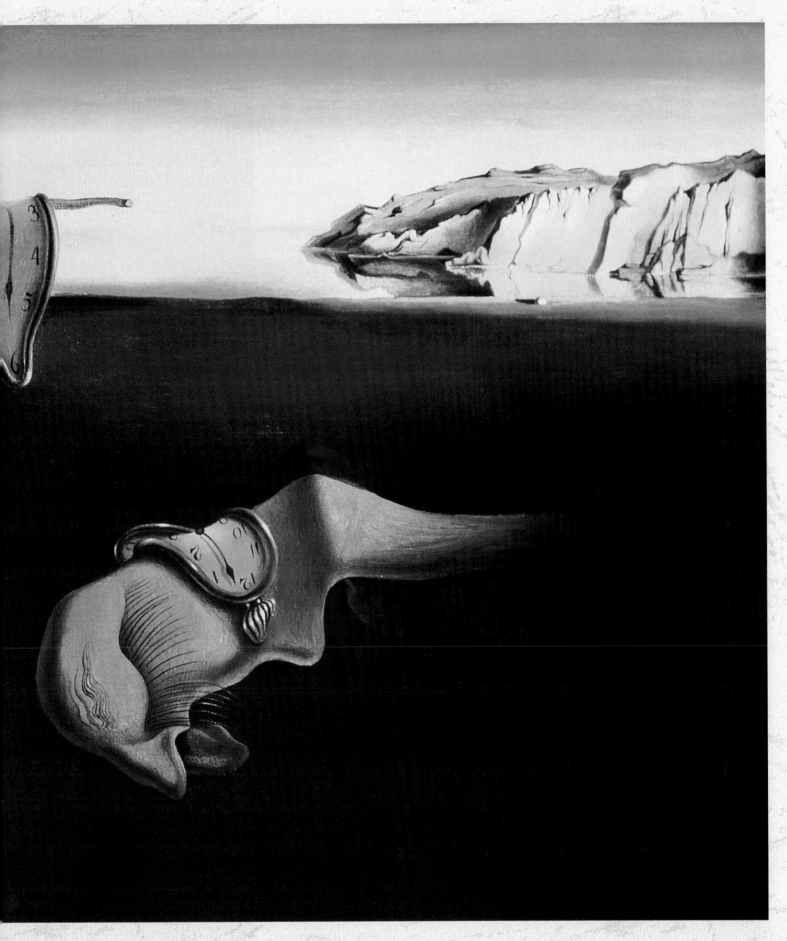

THE PLAY OF TIME

I n 1896 the French philosopher Henri Bergson expounded the theory of dual time: subjective time, formed of the incessant flux of memory, and objective time, which is determinate and measurable. Now investigated in terms of its interior dimension as opposed to the dimension of physical laws, in 1905 the concept of time also underwent a revolution in the context of science: with Einstein's theory it was no longer absolute, but became a dimension that varies, like space, according to the position of the observer.

● Dalí, who was susceptible to this cultural climate, interpreted it through Freud's discovery of the unconscious. He believed the

◆ EXTERNAL TIME AND INTERIOR TIME
In order to represent interior time visually, Dalí draws inspiration from the melting of Camembert cheese. To evocative effect, he melts the watches into soft shapes. Only one of the four watches in *The Persistence of Memory* has a rigid face.

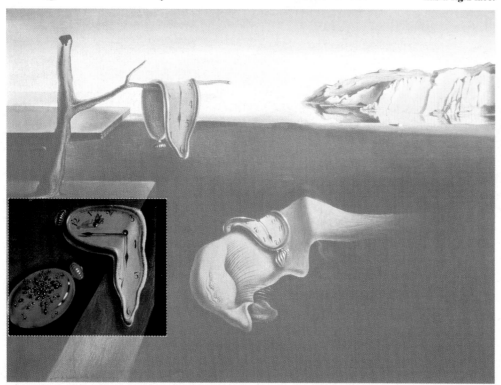

analysis of the individual consciousness to be more important than the reality of external time, and described it as it oscillated between the lucidity of wakefulness and the confusion of sleep or delirium.

● The subtitle of the painting, *Highs and Lows of Memory*, explains the presence of an outline similar to a face with its eyelashes lowered (see the following page) as if asleep. For while the rigid watch points to the activity of the lucid mind, the fluid watches describe the state of the memory when it is confused, as happens above all in the oneiric phase that the figure represents. The process of liquefaction that links the forms painted in Dalí's works and dissolves their identity returns them to their primordial state.

And yet the scene seems to be fixed in a timeless dimension. The limp watch, in fact, no longer indicates the passage of the hours but – since it is the individual who defines the rhythm of time – represents the psychological aspect of individual evolution. It becomes a metaphor of the flexibility of time.

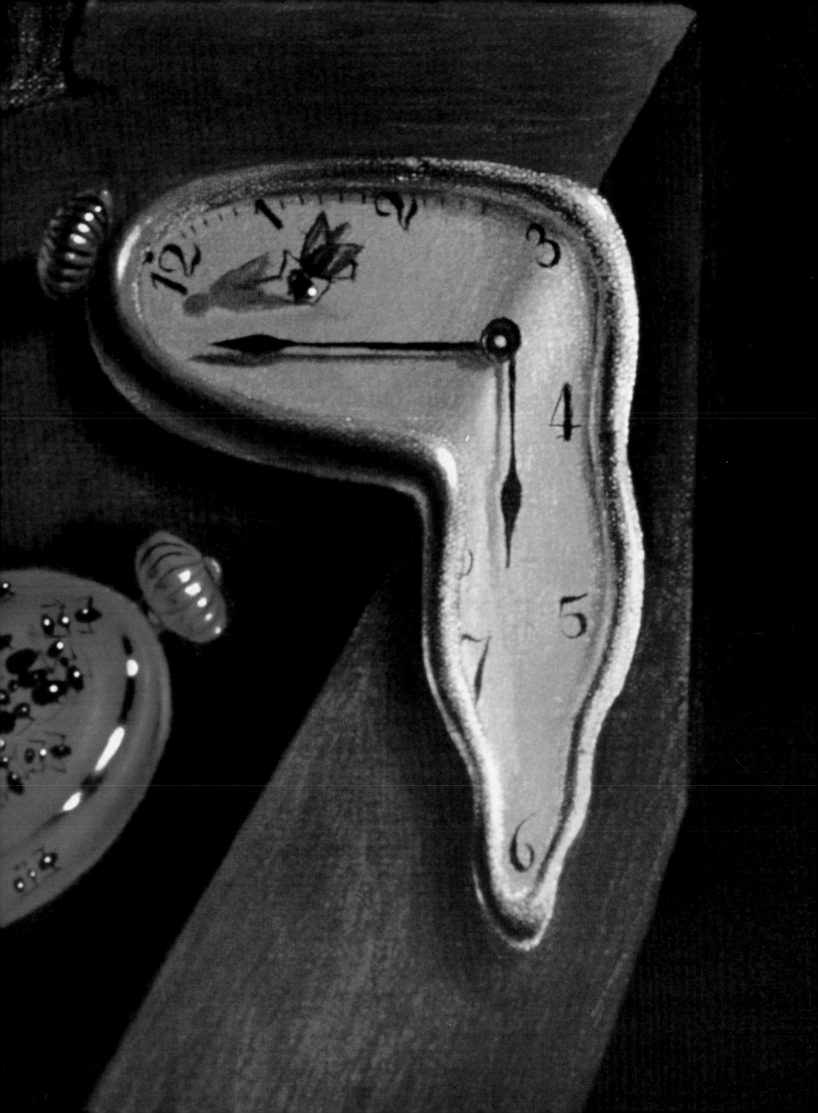

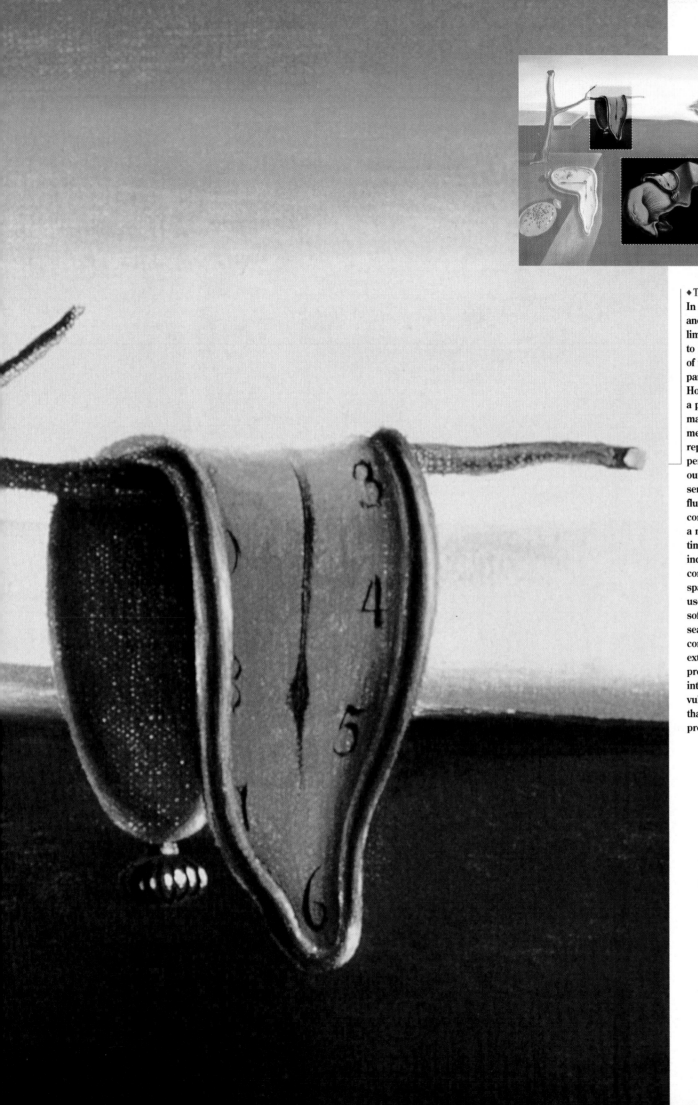

◆ THE LIMP WATCH
In terms of structure and consistency, the limp watch is unsuited to marking the passage of time: it is, in fact, a paradox in itself. However, it ceases to be a paradox if, instead of marking out time mechanically, it represents the interior perception of time, outside the laws of sensible reality. The fluidity of the watch corresponds, in fact, to a non-rigid principle of time, in which the individual consciousness dissolves space and time. The use of forms that are soft and hard, like the sea-shell, reflects the contrast between an external shell that protects, and an internal shell, vulnerable and fragile, that needs to be protected: the psyche.

◆ THE DREAM
The outline of a face with its eyelashes lowered is the representation of the oneiric phase of sleep. The eyes are closed to external reality and open to interior visions, completely unbound by rationality and floating in a timeless dimension that springs from the projection of the unconscious, where past, present and future do not exist.

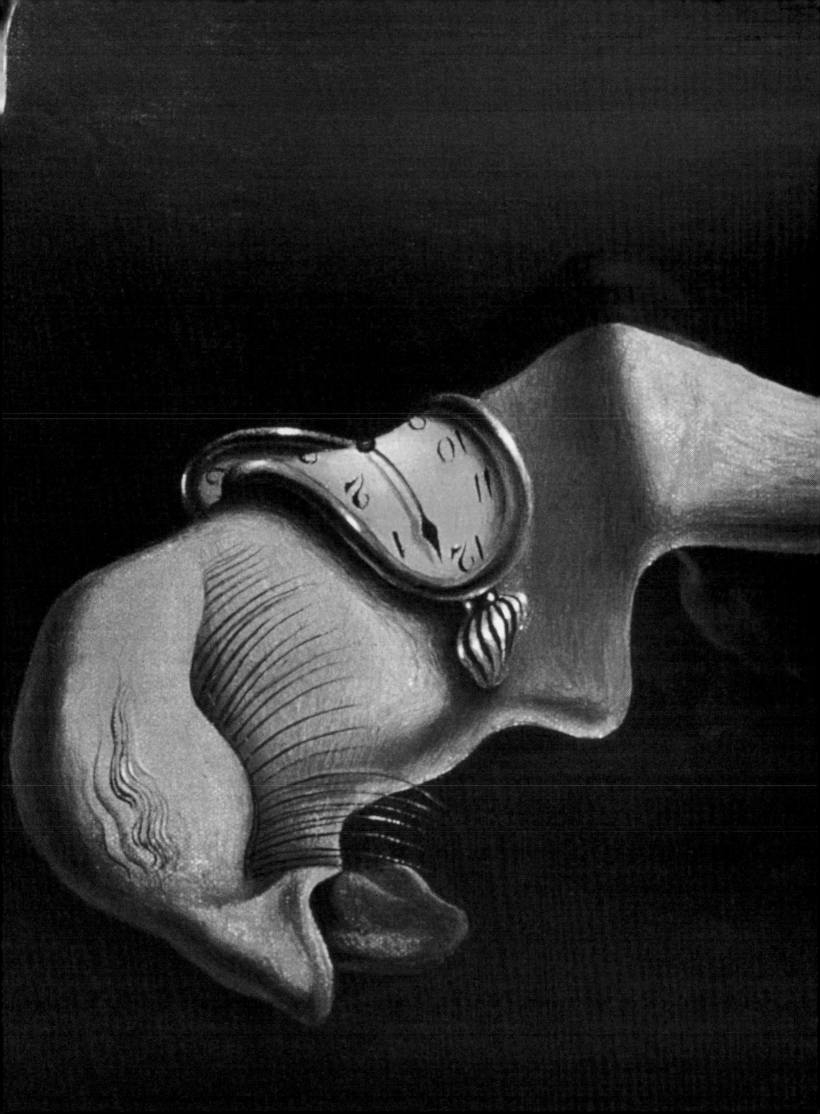

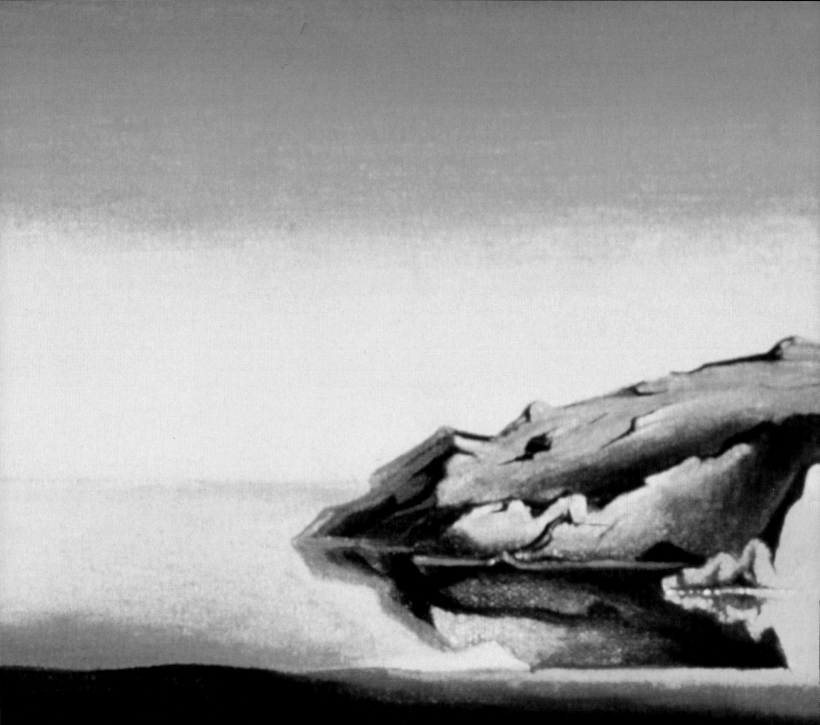

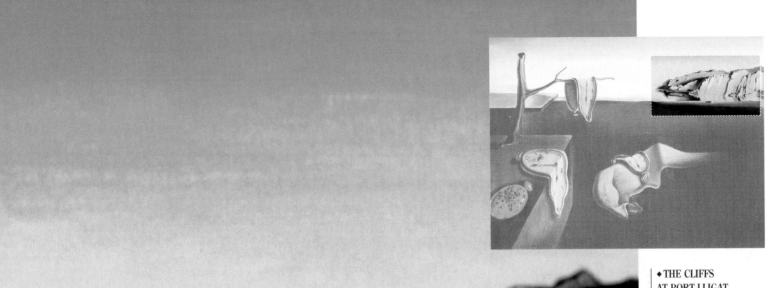

◆ THE CLIFFS
AT PORT-LLIGAT
The detail
represents
the first nucleus
of the painting,
as Dalí himself
pointed out in one
of his writings.
The artist was
perfectly aware
that the landscape
with the cliffs
of Port Lligat,
in a "clear,
melancholic dawn"
light, had to serve
as a background
for an idea that
had still not been
revealed. Suddenly,
in the confused
instant in which
we slide into sleep,
this idea materialized
in a vision of limp
watches.
Dalí transfigured
the violent light
and the jagged
outlines of the
Catalan landscape,
which he had
known since
his childhood,
into an oneiric
vision: "Spain
is the most irrational
and mystical
country in the world."

BACKGROUND SCENERY

As if to underline their cosmic character, Dalí's paintings are almost all exteriors, and possess an unmistakable spatial construction that repeatedly uses wide expanses of desert. Conceived as dusty, arid landscapes, apparently fantastic, in actual fact they are inspired by the rocky landscape and coastline of Catalonia, his native land at the foot of the Pyrenees.

● In his work in the thirties, he sets out from precise notations, and transforms the perspective into spatiality, creating a personal transfiguration of Catalonia. In the attempt to depict his interior

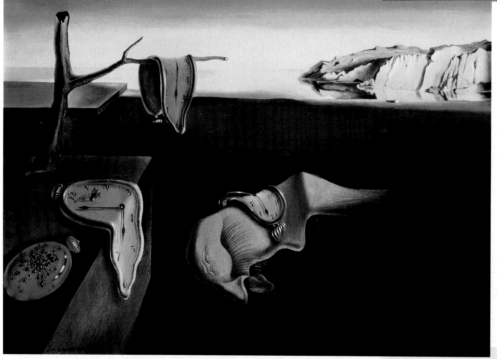

◆ THE ENIGMA OF MY DESIRE (1929, Munich, Staatsgalerie Moderner Kunst). The soft profiles of the rocks, based on the Cadaques coast, are transfigured by the unconscious, as revealed by the obsessive repetition of the words "my mother".

◆ YVES TANGUY *Legacy of Acquired Characteristics* (1936, Houston, Texas, the Menil Collection). Compared to Dalí, the French painter reduces nature to the status of a background that he populates with abstract oneiric figures.

◆ ATAVIC RUINS AFTER THE RAIN (1934, New York, Perls Galleries). According to Dalí, this is the most concrete and objective landscape that exists. Its profile is the only one he loves, and he portrays its wild appearance, like the violent light, sometimes leaden and sometimes warm, almost dazzling, in an obsessive manner. From its jagged coastline, which he defines as "geological delirium and source of desire", he draws inspiration for his surreal visions.

world and his passions on canvas, in *The Persistence of Memory* Dalí gives a solid appearance to that which is born of the earth and possesses a spatial dimension, like the rocks and the expanse of water in the background: all traces of biomorphic or oneiric life, on the other hand, are molded into ductile, almost elastic shapes.

● Among his Surrealist colleagues, similar settings are found in the work of Yves Tanguy, the only one who paints irrational forms in spaces which, albeit sidereal and far from reality, are reminiscent of desert lands. Tanguy creates haunted, skeletal shapes that are sometimes strikingly similar to many of Dalí's deformed objects.

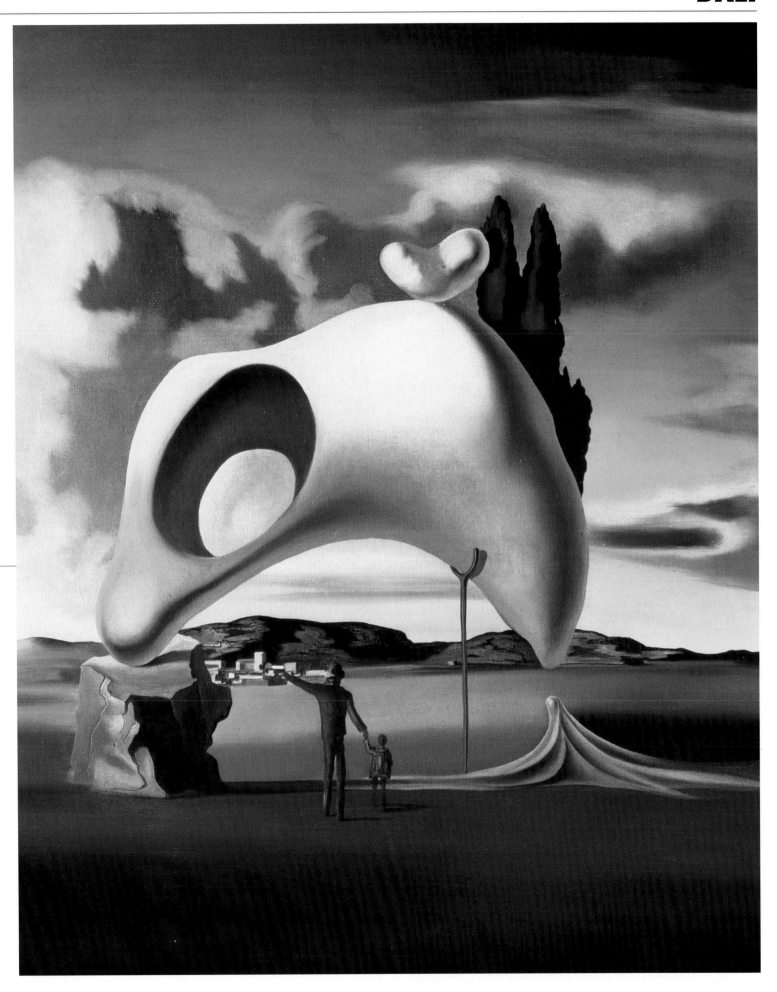

THE HIDDEN SELF-PORTRAIT

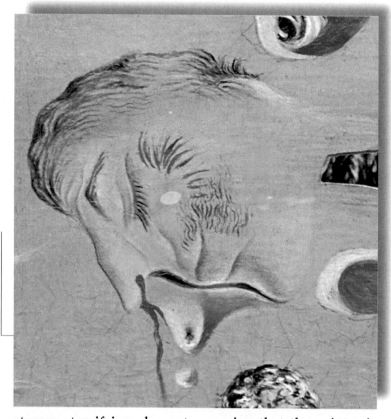

The effect of alienation of the landscape explodes in the center of the painting in a distorted face that collocates the image in a fantastic dimension. The features of the face repeat the soft modulation of the rock below and seem to blend into the ground, and yet we can clearly make out the eyelashes, an eye, the nose and the fold of the mouth. A rapid comparison shows that this profile is actually a recurrent motif in the works from the thirties, and conceals a self-portrait of the artist.

● In early Dalí, in fact, art is a key to interior reality, and becomes a means of exploration of the unconscious. It is therefore natural to find his face collocated in oneiric scenes such as that in *The Persistence of Memory*: it almost constitutes a signature that points to the origin of the work in his own unconscious.

● The features are always contorted and surrounded by

◆THE CENTRALITY OF DREAMS
The detail is part of *Illuminated Pleasures* (1929, New York, Sidney Janis Collection). The head is placed in the center: other images are spread around it, apparently unrelated to each other, as happens in dreams.

strange, terrifying elements, proving that the painter is not only the source but also the victim of the nightmares he represents. He seems to paint a reality in which everything is in a perpetual state of transformation. Contaminated by ambiguity, his forms are changing, multiple images able to show different realities. From the moment he discovered the theories of Freud, in fact, Dalí regularly performed self-analysis, thus learning to recognize and paint his obsessions and their meaning.

● A common characteristic of the masks of his face is the closed eye which he uses to emphasize the phase of sleep, when the unconscious rises to the surface and unleashes secret impulses and suppressed desires. This is the mo-

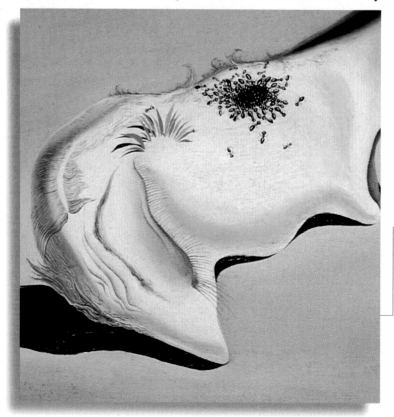

◆THE LIFE OF THE INANIMATE
Like nightmares, the ants torment the sleeper, whose head extends into an inanimate material, a giant formation of liquid with a hole in the middle. The detail is taken from *The Enigma of My Desire*.

ment when the individual, far from the control of the outside world, is returned to the universe of the irrational. The presence of the limp watch, as well as pointing to the ephemeral duration of life, like a *memento mori*, also underlines the subjective character of time and its dependence on the consciousness.

◆THE HEAD LYING
ON ITS SIDE
The oval on the opposite
page shows a detail
from *Cenicitas* (1927-28,
Madrid, Museo
Español de Arte
Contemporánea). In the
paintings from the
thirties, the motif of the
head in a lying position
appears frequently, with
clear reference to sleep
and thus to dreams,
from which Dalí's
visions originate.
Subsequently, as in
The Persistence of Memory,
Dalí adds the presence
of ants to the head,
indicating the corruption
to which man is subject
as a result of the action
of time: the fly, on the
other hand, is the
irritating symbol of brief
interior time.

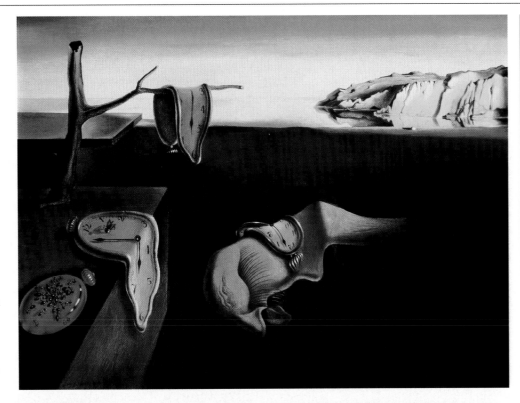

◆THE GREAT
MASTURBATOR
(1929, donated
by Dalí to the Spanish
state). The image
has disturbing power:
the proliferation
of nightmares that
emerge from the
human head also
includes the woman,
who becomes an
image of horror.
The female bust,
an ectoplasmic
extension of the
sleeper, has the
consistency of a ghost,
behind which we can
make out the shadow
of a destructive
maternal element.
The traces of blood,
on the other hand,
allude to castration and
to the fear of punitive
paternal judgement.

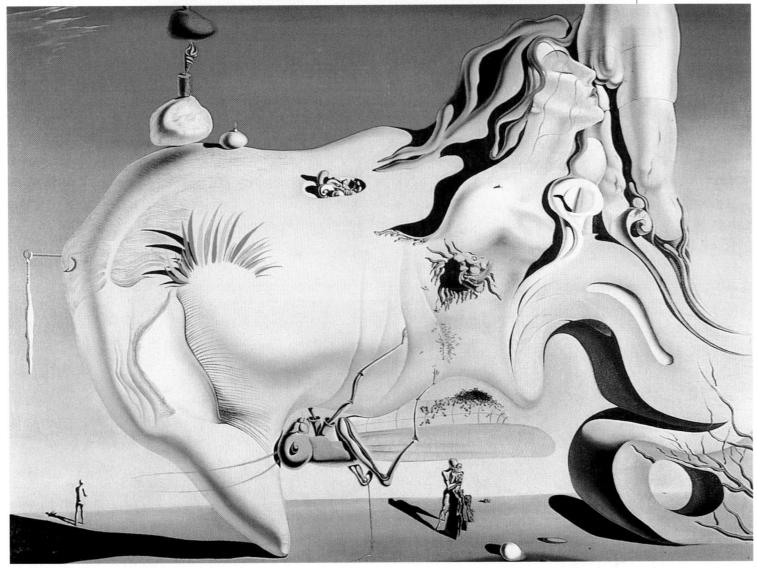

THE ART OF PROVOCATION

When Salvador Dalí was born, in 1904, he was baptized with the same Christian name as his brother, who had died of meningitis at the age of seven. This situation, which turned him into a substitute and charged him with the duty of living for his dead brother, was cited by Dalí as the cause of his egocentricity.

● As he recalled in his autobiography: "In being born I followed in the footsteps of my adored dead brother, who they continued to love through me. […] All my consequent eccentricities, all my incoherent exhibitions, have been the tragic constant of my life: I had to prove to myself that I was not the dead brother, but the living one. As happened in the myth of Castor and Pollux, by killing my brother within myself I gained my permanent immortality."

● His narcissism gradually turned from arrogance to pure fanaticism. Even his physical appearance and his dress created a new fashion. With his extravagant and above all highly visible actions, Dalí showed that he was able to use any means possible to cause scandal and that he was well aware of the mechanisms of publicity. His figure is, in fact, surrounded by an incredible number of anecdotes, some of the them false, which were deliberately divulged by the artist himself.

● His propensity to astonish people and his exaggerated self-ostentation led him to be defined as a genius, but also as a lunatic or a megalomaniac. In order to underline the conscious, intentional nature of his provocation, Dalí stated that: "The only difference between me and a madman is that I am not mad!" It is also no coincidence that he chose the title *Diary of a Genius* for his autobiography.

● Due to his very commercial self-promotion, André Breton gave him the scornful nickname *Avida Dollars*, an anagram of his name. Dalí, however, did not respond directly to the provocation, for money was always important to him. In fact he also turned his life into a work of art so that it could become the stage worthy of the character that had been created, right up to the final, daring form of spectacle: the decision to place his tomb in a theater-museum in Figueras.

◆ DALÍ THEATER-MUSEUM IN FIGUERAS
The museum, housed in a theater that had burned down during the war, was opened in 1974. The eggs are primordial symbols often used by Dalí in his works.

◆ ART AND CINEMA
The image below is taken from a frame of the film *Un chien andalou* **(1929) directed by Luis Buñuel and Salvador Dalí.**

CINEMA WITH BUÑUEL

"Every cinematographic image is the capture of an incontestable spirituality." Dalí's enthusiasm for the cinema stemmed from his meeting in 1921 with the director Luis Buñuel, who revealed the potential for expression of the new medium. Together the two Spanish artists made two films with clear Surrealist features: *Un chien andalou* (1929) and *L'âge d'or* (1930), in which the painter Max Ernst also appears. Audiences were shocked by the irrationality and the violence of some scenes: an eye cut by a razor, a hand covered in ants. The second film was even censored due to its iconoclastic power. And yet the surreal character of the images even left a trace in the films of Hitchcock, who in 1945 invited Dalí to collaborate on the dream sequence in *Spellbound*.

◆ NARCISSISM AND TRANSGRESSION
The photo on the opposite page, taken in 1961, captures the painter in the intimacy of his studio, while in the background we can make out a painting by Velázquez to the left. The vulgarity and brilliance with which Dalí imposed his image on the public were part of the contradictory nature of a figure who managed to combine reality and madness, poetry and drama, in his art.

FROM REALISM TO THE PARANOIAC CRITICAL METHOD

During his early development Dalí sifted through tradition and was very much aware of contemporary trends, but subverted these influences through the Surrealist style, which reached its peak in the late twenties and early thirties. His originality subsequently gave way to an obsessive repetition of the same themes and forms, with tones that come close to the kitsch and the grotesque; at the same time he underwent a religious conversion that was to explode in the monumental canvases of the fifties.

● His early studies took place at the Academy of Fine Arts in Madrid, where he remained from 1922 to 1926, when he was expelled as a result of his rebellious behavior. Albeit in a more superficial manner, his early works reflected the Cubist style, especially the work of his fellow Catalan Picasso (*Self-Portrait with "Publicitat"*, 1923).

● Through careful study of the Renaissance and Mannerist masters, his style slowly took form, giving rise to works of a calm, stud-

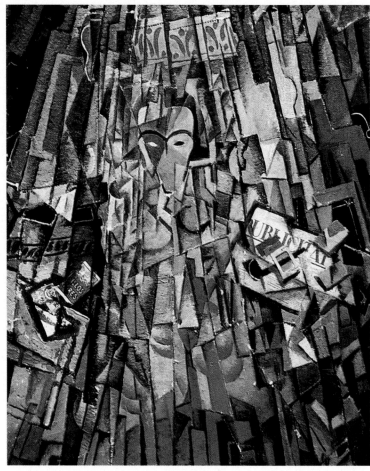

ied realism that gives no indication of the surging fantasy that would soon invade his canvases (*Girl at the Window*, 1926).

● When, following the ideas of Freud and of his friends Federico Garcia Lorca and Luis Buñuel, he finally embraced Surrealist esthetics, Dalí maintained the reference to natural data, but created a psychic alienation that turned reality upside-down: extravagant juxtapositions and hallucinations were the faithful transcription of his dreams (as, for example, in *The First Days of Spring*, 1929).

● Dalí's main contribution to Surrealism was the invention of the *paranoiac critical method*, with which he responded to the automatism proclaimed by his colleagues. Dalí himself explained the meaning of the term: "It is the spontaneous method of irrational knowledge based on the interpretative-critical association of the phenomenon of delirium." In short, he proposed a visionary painting that combines multiple realities and dream, man and nature: thus every image can conceal another (as in *Ghost Cart*, 1933).

◆ GIRL AT THE WINDOW
(1925, Madrid, Museo
Español de Arte
Contemporánea). In
this painting, Dalí
portrays his sister Ana
Maria, fascinated by the
relation between the
figure with her backed
turned, looking out of
the window, and the
landscape. The work is
still influenced by the
realism of the "return
to order" of the
twenties. The painter
uses a clear, bright
palette, whose luminous
quality would be
maintained in his
subsequent output.

◆ SELF-PORTRAIT
WITH "PUBLICITAT"
(1923, Figueras,
Teatro-Museo Dalí).
Dalí was not immune
to the influence
of Cubism;
this self-portrait
is surprisingly
reminiscent
of the paintings
of Picasso. From
his fellow Catalan
he took up the mixed
technique of gouache
and collage
on cardboard
and the motif
of the newspaper.

◆ PORTRAIT
OF LUIS BUÑUEL
(1924, Madrid, Centro
de Arte Reina Sofia).
The work is influenced
by De Chirico
and by the climate
of the "return to order"
of the post-war years,
when the revolution
of the avant-gardes
was replaced by
a move back towards
realism. Dalí met
Buñuel at the Academy
in Madrid; together
they made two films
that belong
to the avant-garde
of·Surrealist cinema.

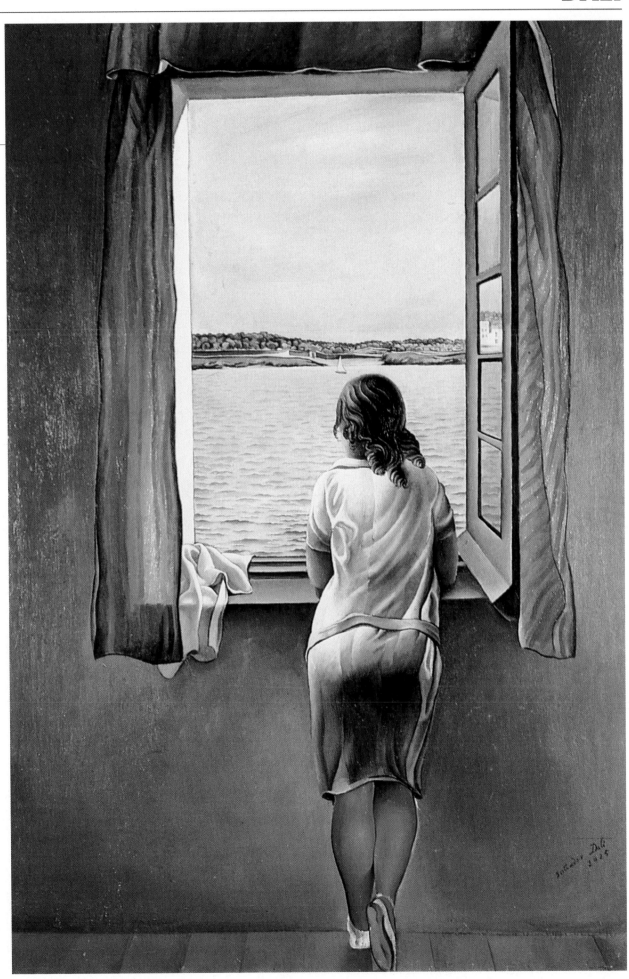

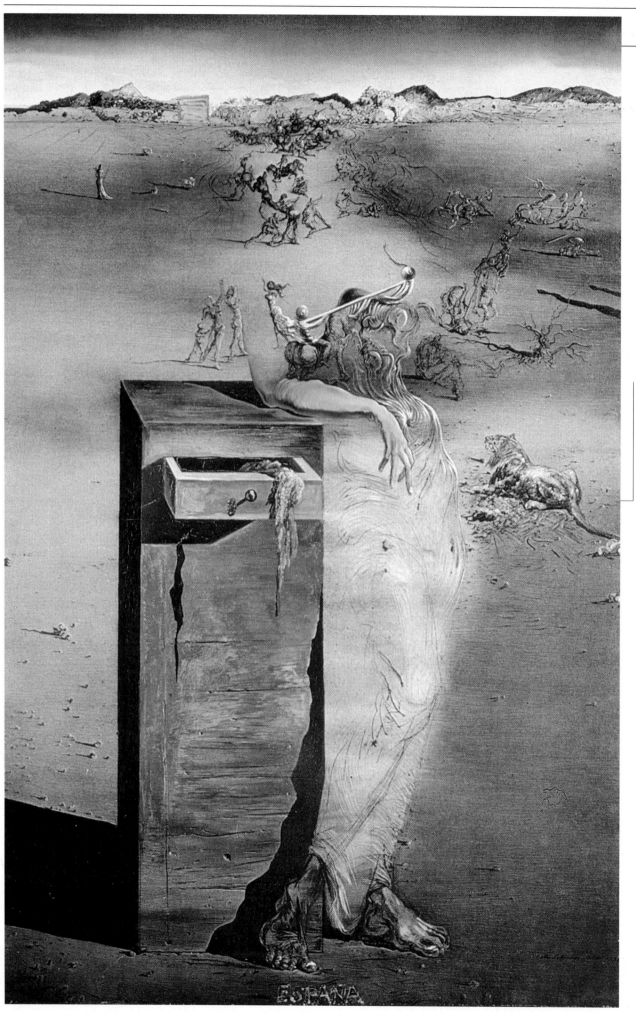

ESPAÑA

◆THE LAST SUPPER
(1955, Washington,
National Gallery of Art)
The work belongs to
Dalí's religious phase,
which began towards
the end of the forties,
in contrast with the
blasphemous
provocation of his
previous work.
The painter repeated
themes taken from
the Bible and turned
them into monumental
apotheoses, where
large-size canvases
are suddenly crowded
with figures.

◆SPAIN
(1938, Rotterdam,
Boymans-van
Beuningen Museum)
Dalí never expressed
a position with regard
to the Spanish
Civil War, and yet
the horrors of the
conflict exalted his
esthetic research.
His style at this time
also involved
a reworking of elements
of sixteenth-century
culture: in the
background of this
painting there
is a reference
to Leonardo da Vinci's
Battle of Anghiari.

◆FIGURE AMONG
THE ROCKS
(1926, St. Petersburg,
Salvador Dalí Museum)
The canvas was strongly
influenced by Dalí's
fellow countryman
Picasso, and displays
the raw creative power
he aspired to.
The figure dominates
the surface through
its diagonal pose
and the plasticity
of the forms.
The harsh features
seem to echo the
asperity of the rocks,
a reference to the
Cadaques landscape.

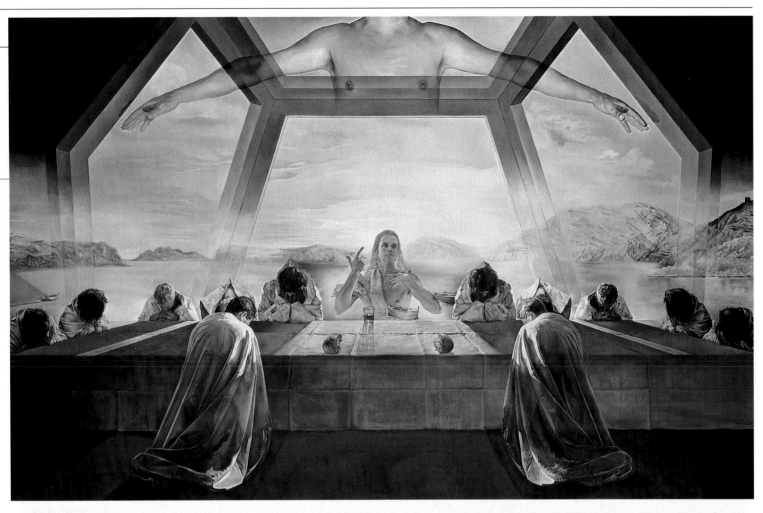

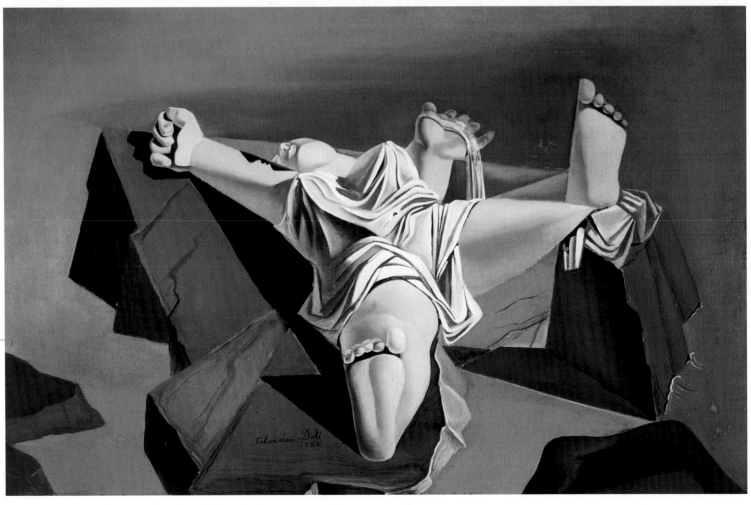

ANAMORPHOSIS AND METAMORPHOSIS

For Dalí nature is continually changing, and possesses an unstable physiognomy that is ready to be contradicted by his imagination. Vegetable, animal and human elements combine happily, sometimes to lyrical effect, sometimes with more disturbing results. This is the principle of *concordia discors*, professed above all by the artists of the sixteenth century, with lively correspondences between the part and the whole.

◆ ARCIMBOLDO
Spring
(c. 1591, Paris, Louvre). Court painter to Rudolf II in Prague, he is well-known for his portraits composed of fragments of natural elements. Dalí imitated him in *Woman with Head of Roses* (1935).

● Dalí made a careful study of the great masters of the past, and his painting re-

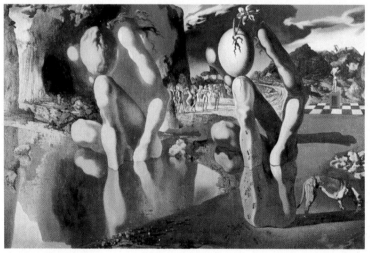

◆ METAMORPHOSIS OF NARCISSUS
(1937, London, Tate Gallery). The painting plays with stereophonic effects: the outline on the left of the young Narcissus is repeated on the right, where it becomes a hand holding a narcissus bulb.

veals the influence of Mannerism, clearly visible in the ludic, ambiguous conception of the forms. His main point of reference is the painter Arcimboldo, whose original metamorphoses stimulate the imagination and present a new, seductive image of nature. From Arcimboldo, Dalí learned distorting techniques such as anamorphosis, the reconstruction of the human figure through bizarre elements (fruit and flowers).

◆ ANTONI GAUDÍ
Sagrada familia
(1909-26, Barcelona). The imposing church (below) is one of the most powerful examples of Spanish modernism. Gaudí showed Dalí how to transfigure nature, with absolute freedom of expression, creating fantastic decorative motifs.

● Having appropriated the Baroque principle that "The end of wonder belongs to the poet", Dalí transfigured reality following the example of Gaudí and invented forms halfway between reality and vision, where historical references blend with animal or vegetable elements. He thus began to create multiple images, where each representation contains ambivalent motifs that animate nature and invite the viewer to discover the trick. *Trompe l'oeil*, stereoscopic vision, palindromes, Baroque-style distorting mirrors, errors or optical illusions based on reflections: the Spanish artist used every means possible to multiply the planes of reality and to surprise the eye of the viewer with visual *calembours*.

● Through his surreal manipulation of nature, Dalí thus went beyond the confines of the concrete and began to play with metaphor and evocative effects. Seemingly without altering any details, he gave nature a dual form, creating two opposing entities. Through these images he visualized his paranoiac method, in which a mind allowed to roam freely, setting out from perceptive data, proceeds by means of unconscious associations. Thus, by filling the stage with the various aspects of a many-sided reality, Dalí invites the viewer to explore its fantastic potential with his own imagination.

◆ SWANS REFLECTED IN ELEPHANTS
(1937, Geneva, private collection). The work is one of Dalí's most poetic optical illusions. The reflection of the swans in the water combines with that of the trees to create surreal elephants: an application of the paranoiac method.

◆ SLAVE MARKET WITH THE DISAPPEARING BUST OF VOLTAIRE
(1940, St. Petersburg, Salvador Dalí Museum). The image plays with the features of the French philosopher drawn from the bust made by Houdon, but rendered through the surreal juxtaposition of atwo figures in Dutch costume. The subject of the slaves is almost marginal, among figures in tormented poses.

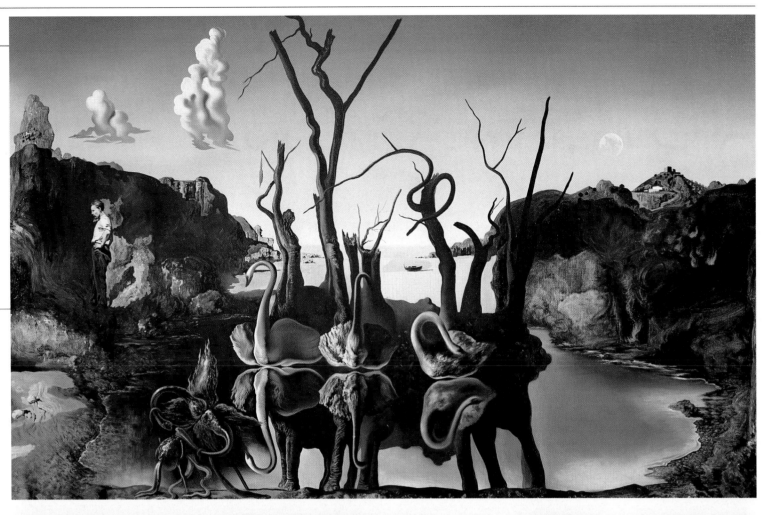

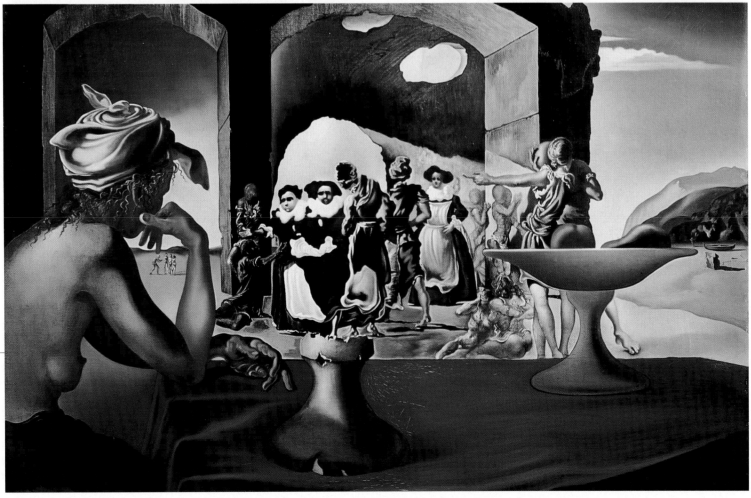

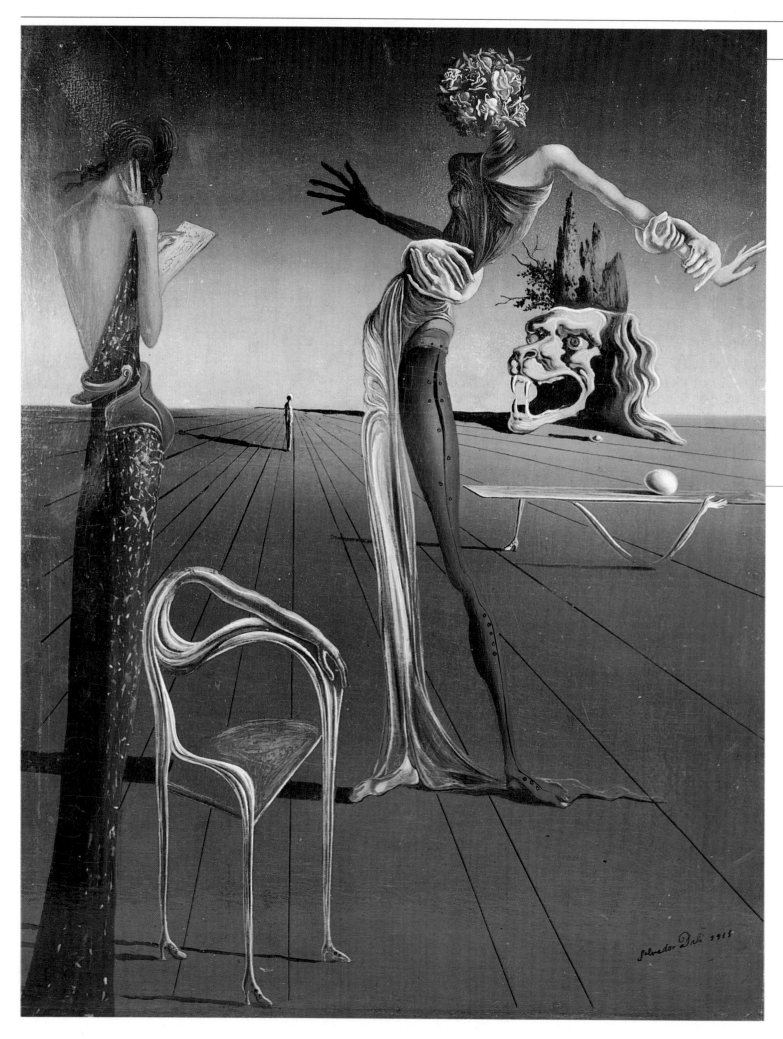

♦ PARANOIAC FIGURES
(1934-35, Figueras, Dalí Foundation). The image repeats the anthropomorphic landscapes typical of the Mannerists: viewed horizontally, in fact, it represents a landscape, while vertically it outlines the features of a human face. Through a refined optical effect nature can be observed in all its richness.

♦ WOMAN WITH HEAD OF ROSES
(1935, Zurich, Kunsthaus). The painting blends metaphysical influences, evident in the theatrical framework and the dummy-leg of the main figure, with the long-limbed shapes of the Mannerists, which Dalí had taken mainly from the tapered figures of El Greco. The dominant feature, however, is the fantastic *trompe l'oeil*: the human blends with the inanimate in the chair with the arm, and also in the table with the hand. The head of the woman in the center, on the other hand, is conceived like Arcimboldo's *Spring*.

♦ THE NEVER-ENDING ENIGMA
(1938, Madrid, Centro de Arte Reina Sofia). The multiple image exemplifies Dalí's ability to play with the expressive potential hidden in reality, and illustrates the paranoiac critical method in the manner of a manifesto. Here, in fact, we can make out a face, the outline of a dog, the profile of a boat with a small figure next to it, and finally a man bending over. Reality undergoes a constant metamorphosis and becomes a never-ending enigma.

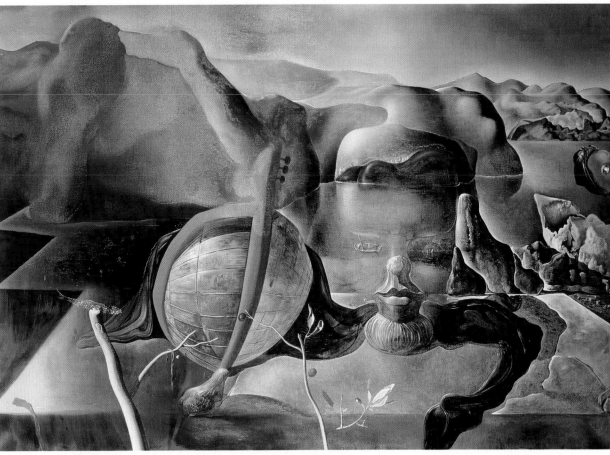

THE OBSESSION WITH GALA

When Dalí met Gala in 1929, his insecure personality found in her a way to make up for his own weaknesses. Gala, the daughter of the Russian lawyer Diakonoff, was thirty-five, ten years older than Dalí himself, and had a strong, determined and extravagant character. Struck by her sophisticated beauty, compared to which he was merely a young man from the provinces, he handed her the reins of his creativity and his life, until ultimately he became captivated, his every action performed under her control.

◆A MORBID LOVE
Dalí wrote that: "Gala saved me from my self-destructive instinct." Their relationship was characterized by its extravagance. Although they were inseparable, they both had numerous extra-marital affairs.

◆GALARINA
(1944-45, Figueras, Dalí Foundation). In this portrait, in which Gala reveals her powerful sensuality, Dalí plays with his wife's name, which can also mean "milk", alluded to by her bare breast.

● Because of Gala Dalí fell out with his family even before their marriage, which took place in 1934. Gala, in fact, had been married since 1917 to the Surrealist poet Paul Eluard, and when she met Dalí in Paris she was also the mistress of the Surrealist painter Max Ernst. She had a willful personality, and was considered audacious because she managed to fulfill her every desire. Gala became the artist's muse, his companion, his manager, his support, and his obsession. With her he gave free rein to his morbid sexuality, transforming her into an avid object of desire, as when he portrayed her with some cutlets on her shoulder, indicating his yearning desire to bite her. At the same time he raised her through his worship to angelic levels, often even depicting her in the mystical guise of the Virgin Mary.

● The appearance of Gala on the scene marked the beginning of the golden phase of Dalí's work, almost as if he finally felt confident about his eccentricities. Gala's face appeared more and more often in his canvases, both as a secondary detail and as the main subject, confirming his dependence on her for inspiration. He eventually wove his signature together with her name, a demonstration of the merging of their souls: Gala was truly his soul-mate. Although they were inseparable, Dalí's ostentatious behavior was very different from the more reserved manner of his wife, who supported him publicly and passionately, but preferred to live in the background.

● Soon, with moneymaking aims, Gala turned Dalí's unruly genius into a production line of images for the purposes of publicity, and directed his uncontrollable fantasy towards the repetition of motifs and forms produced in the thirties. Back in Europe after their long spell in America, the couple divided their time between the surreal villa in Port Lligat and the castle in Pubol (which Dalí gave to his wife). Gala died in 1982, and without her Dalí's creative flame ceased to burn.

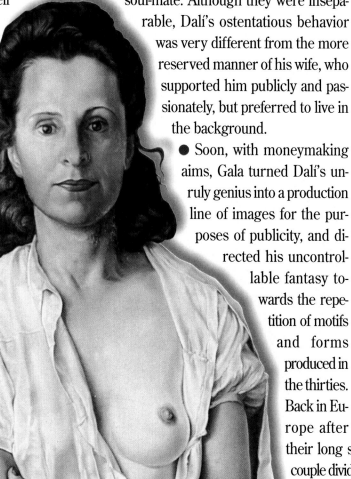

◆ATOMIC LEDA
(1949, Figueras, Dalí Foundation). In a mythological transposition, Gala is portrayed here as Leda, seduced by Zeus in the guise of a swan. Dalí sees the myth as a reflection of his relationship with Gala: from the relation with Leda a swan is born, which in turn generates two eggs with the twins Helen and Clytemnestra, Castor and Pollux. For Dalí Gala is the indivisible twin. In the canvas the various elements float freely in space, creating an impression of complete absence of gravity. The painting was produced when Dalí became fascinated with nuclear physics, deeply shocked by the first atomic bomb.

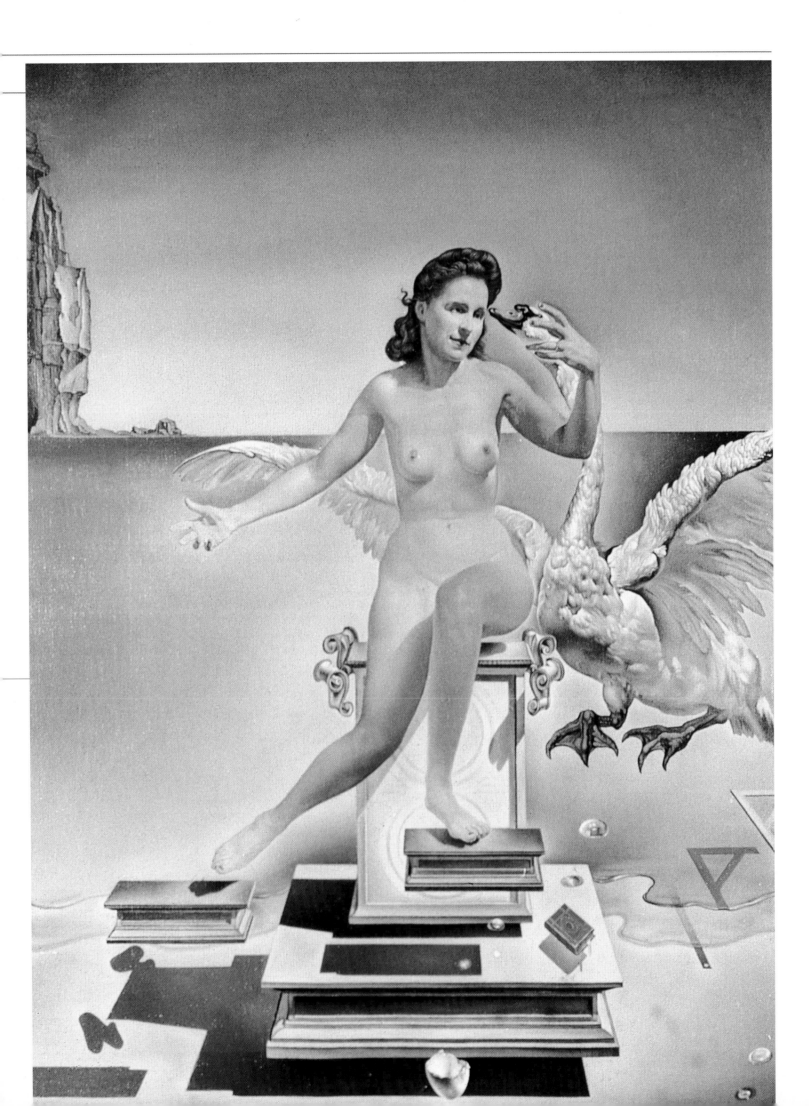

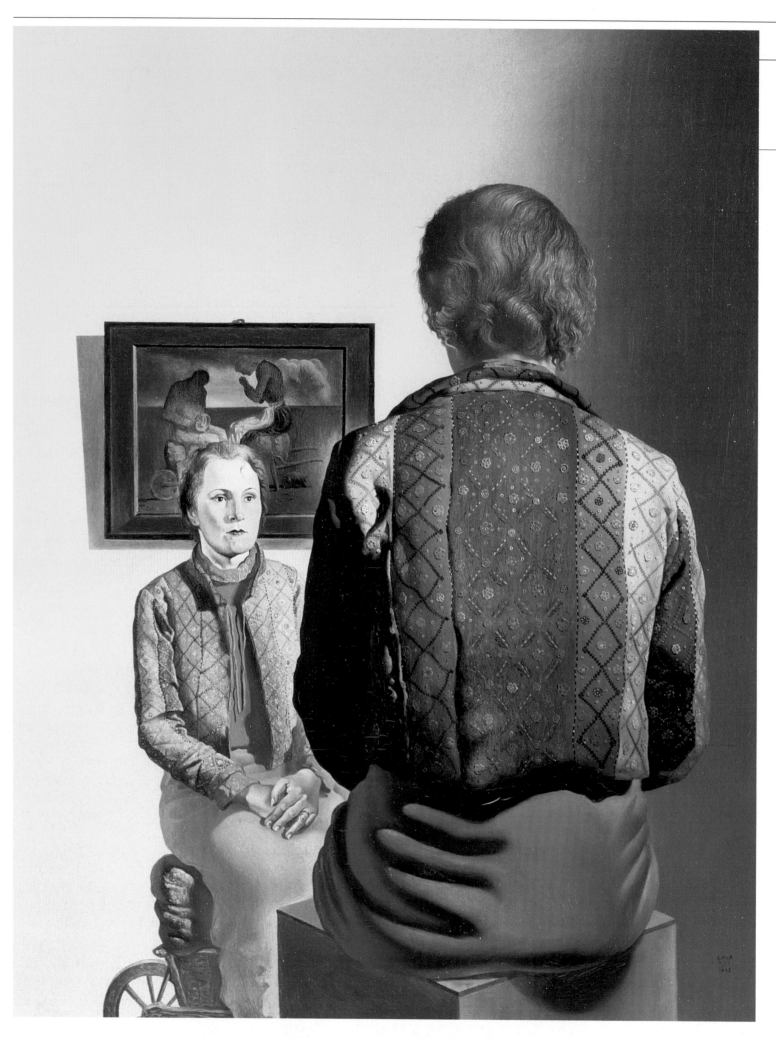

♦ THE ANGELUS
OF GALA
(1935, New York,
Museum of Modern
Art). The composition
sets the woman in a
traditional framework,
and ennobles her
through the realistic
style and the lively
tones. And yet a trace of

Dalí's unpredictability is
evident in the
juxtaposition of Millet's
Angelus, placed on the
wall: Gala is seated, like
the peasant, on a cart.
The dual pose, facing
the viewer and with her
back turned, is a sign
of the search for three-
dimensionality.

♦ DALÍ WITH HIS BACK
TO THE VIEWER
PAINTING GALA
RENDERED ETERNAL
BY SIX VIRTUAL
CORNEAS TEMPORARILY
REFLECTED
BY SIX REAL MIRRORS
(1972-73, Figueras,
Dalí Foundation). In a
naturalistic manner

reminiscent of his early
work in the twenties,
and also of the Dutch
style of Vermeer, Dalí
plays with the reflection
of mirrors to multiply
reality. The painting in
the painting is a
traditional device that
assumes evocative
power by reflecting the

two faces. As in the
portrait from 1935,
Gala is portrayed with
her back turned, but
the two-dimensional
limit of the pose is
overcome by the mirror
that reflects her face.
The serene atmosphere
is rendered by the light
blue tones.

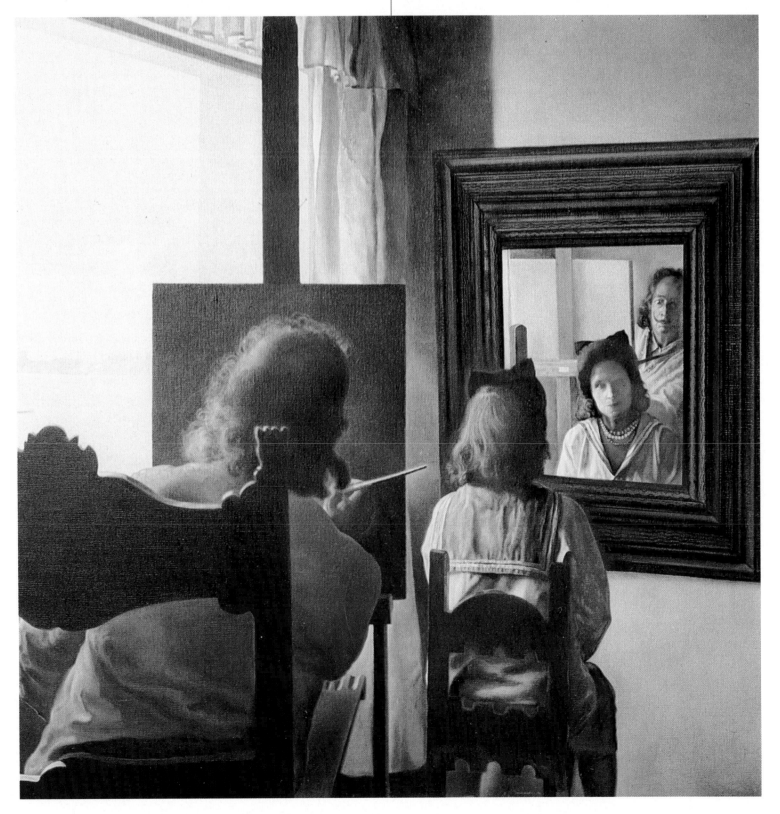

AN EXTREME EROTICISM

Dalí's chaotic universe is pervaded by disturbing atmospheres dominated by two forces in constant tension: Eros and Thanatos, love and death. Pleasure and pain, violence and sexuality alternate and finally become the structural elements of his most strictly Surrealist work of the thirties. His images include sadistic and masochistic scenes that challenge conventions and cause scandal through their open violation of taboos. For Dalí, as for Freud, eroticism was the primary source of nightmares, the unconscious force behind all human actions, the chosen object of desires.

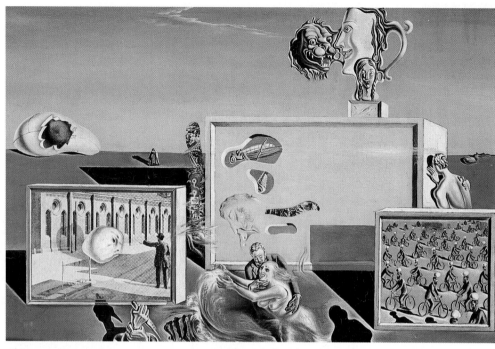

● Before his marriage to Gala, when he portrayed women he described them as devouring ghosts that threaten men. Above all, however, there is an obsessive repetition of the theme of masturbation and the fear of castration, expressed through the patches of blood on the trousers. A sense of guilt accompanies the fear of paternal judgement, the disturbing shadow that haunts Dalí's youth and gives rise to figures who hide in shame.

● Eroticism is thus inseparable from violence, and for this reason his canvases are full of symbols that allude to sexual pleasure or to the voluntary search for punishment: men's hair, birds' heads, stones, daggers. Even the limp forms have been interpreted, due to their liquefaction, as the fruit of autoerotism. These symbols are accompanied by others, like ants, which underline the corruption and decomposition of the flesh.

● From the forties onwards, the macabre, brutal eroticism disappears from the scene, making way for the serenity of religion. Sexuality is now turned outwards, towards the woman, and often uses the rhinoceros horn as an allusive icon.

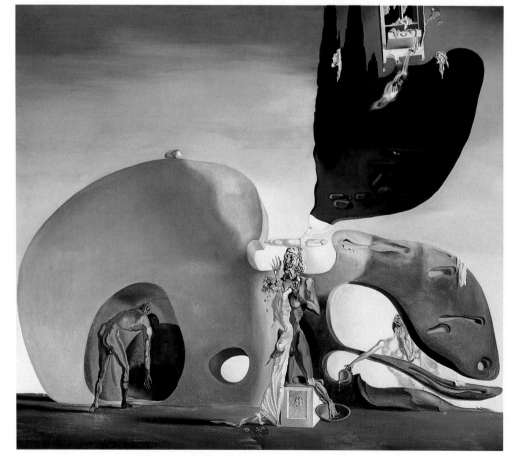

♦ ILLUMINATED
PLEASURES
(1929, New York,
Museum of Modern Art).
In this initial phase of his
research, Dalí revisits a
number of artistic
influences: he returns to
Cubist collage, gluing the
lion's head onto the
painting; he cites Max
Ernst in the column-bird
in the center; he echoes
Hans Arp in the curved
outlines of the blue
canvas; and finally he
recalls Magritte in the
picture of the cyclists.
And yet in this ensemble
there is a clear erotic
intention: the self-
portrait, the rhythmic
movement of the cyclists,
the sense of shame of the
figure hiding, the locust
that obsesses Dalí and
the bloody dagger in the
foreground allude to
autoerotism and to the
fear of punishment.

♦ AVERAGE
ATMOSPHEROCEPHALOUS
BUREAUCRAT MILKING A
CRANIAL HARP
(1933, St. Petersburg,
Salvador Dalí Museum).
The liquefied form of the
skull and the gesture of the
man milking, or playing
the harp poetically, define
the act of masturbation.
The man, in fact, merges
with the outline of the
surreal instrument.

♦ THE BIRTH
OF LIQUID DESIRES
(1932, New York, the
Solomon R. Guggenheim
Museum). The canvas
shows how Dalí conveys
sexual fantasies through
surreal forms. The couple
in the center, where the
motif of Arcimboldo's head
of flowers is repeated,
indicates a violent relation,
and the bread has a
powerful erotic
connotation. The liquid
desires of the title can also
be seen in the limp forms
of the rock and in the
water flowing from the
rock and from the jug.

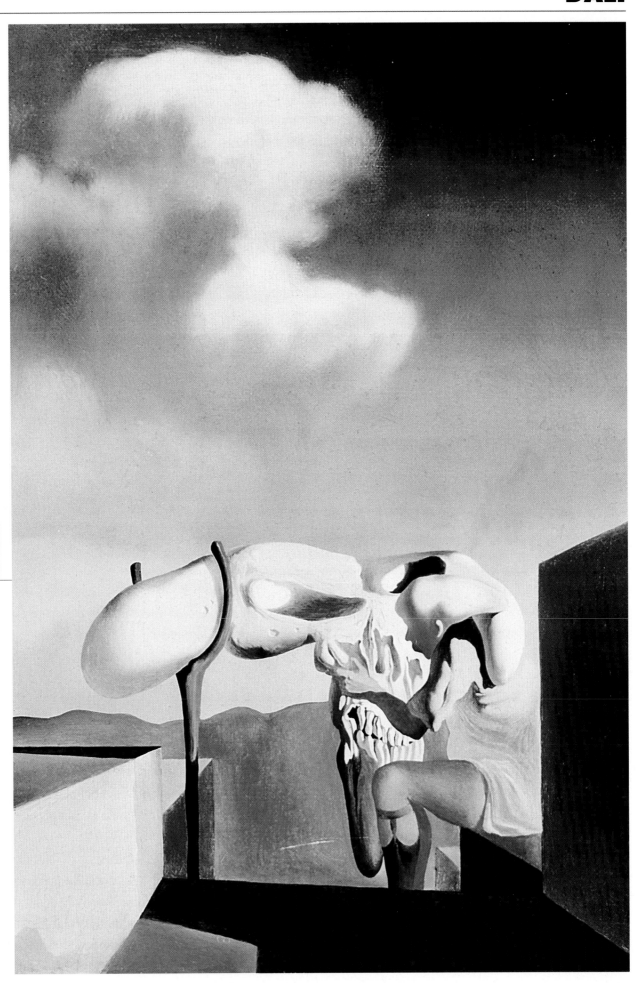

A MORBID ANGUISH

From the unconscious, populated by terrifying demons and distorted forms, there emerge monsters that announce the dissolution of nature. Dalí takes up the lesson of Arcimboldo, Bosch and Bruegel, and creates a fantastic world often characterized by grotesque tones. From the monstrous elements that Arcimboldo used to pleasant effect, the Spanish master drew inspiration in order to create lyrical, positive forms, while in the two Northern European artists he was struck by their common Gothic background. Dalí was fascinated above all by the monsters of Bosch, but

healthy creativity that neither relaxes nor liberates, but frightens both the painter and the viewer. Dalí's fantastic world is, in fact, as concrete as the natural world, and cannot be escaped from.

● An apocalyptic scenario serves as a backdrop to the brutal anatomic dissections which the painter recomposes in arbitrary manner and in vexing poses. Through his monstrous creatures, Dalí pursues the sense of the horrific and the foul. He looks deliberately for irritating, vulgar forms, to which he assigns a desecrating value, and does not refrain from describing scurrilous details such as excrement or the putrefaction of the

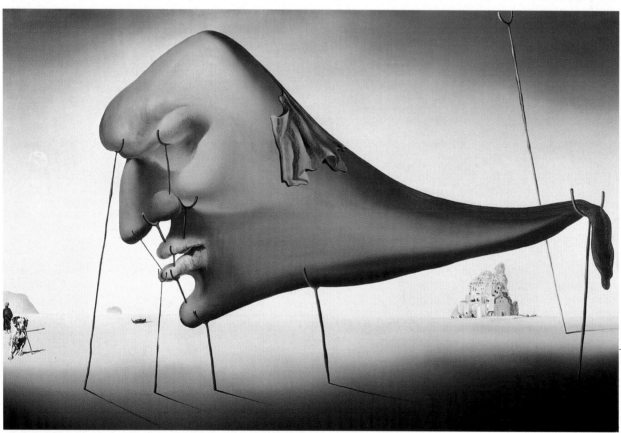

◆ GIRAFFE ON FIRE (1936, Basle, Kunstmuseum). The theme of crutches is applied here to figures with slender shapes and drawers that reveal their unfathomable depth. The crutches show a macabre resemblance to knives stuck into the body. The giraffe, the main subject, is relegated to the background.

◆ SLEEP (1937, private collection). Release from external inhibitions takes place during sleep, when fantasy and unconscious desires take over. However, "In order for sleep to be possible, we need a system of crutches in physical balance." This is why Dalí portrays himself with crutches.

he rejected their moral framework and thus came to define himself as "the anti-Bosch".

● Next to the fluid forms with which he translated erotic themes and the figures that combine human and animal with ironic ambiguity, there appear horrific deformations in which all identity is destroyed. Obsessive images of feeding and amorphous beings held up by crutches, the symbol of a fragile society that needs support, are juxtaposed in the paintings with ants, flies and locusts, demonic creatures in that they attack and corrode all forms. His turbid world thus gives expression to an anguished fantasy, an un-

flesh. His aim is to create forms of a wild character that bring out the obsessive aspect of nature.

● Towards the forties, Dalí's paintings witness the decomposition of man, and by extension of the world, albeit against realistic backdrops. Life and death, sin and punishment combine without hope of salvation against the background of war, the Spanish Civil War and the Second World War. Subsequently his rediscovery of religion, however unorthodox, and his study of science blunted his surreal weapons, thus reducing the horrific, the gruesome and the spectral forms to a more rarefied and calm dimension.

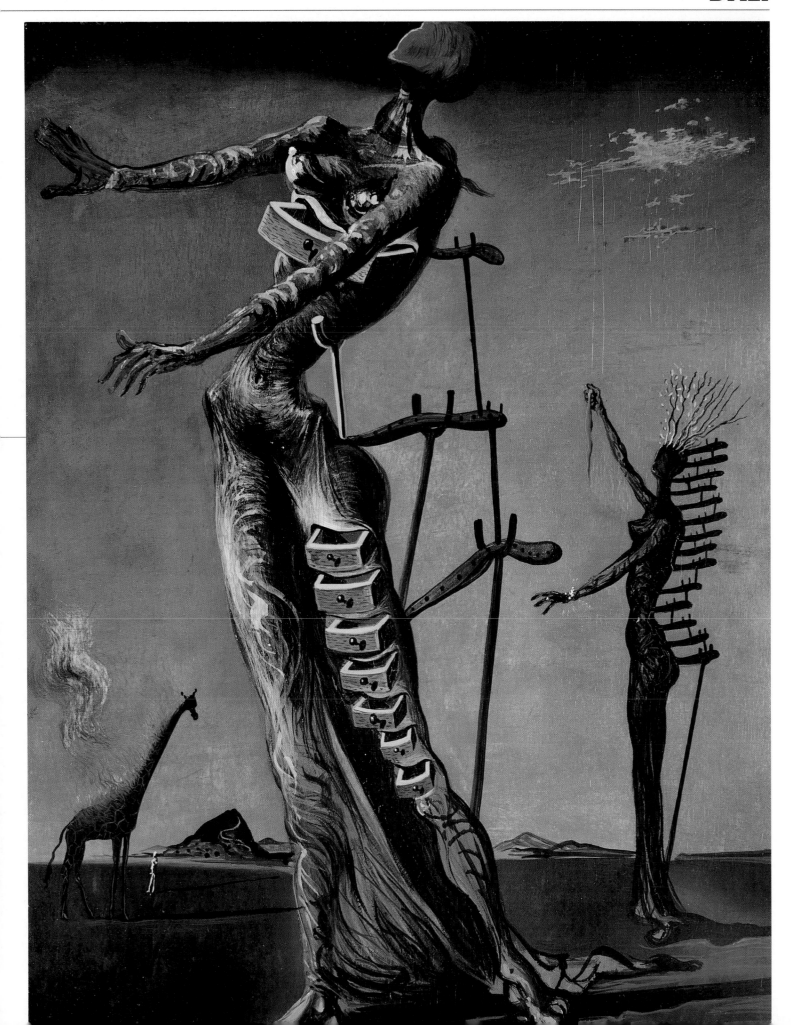

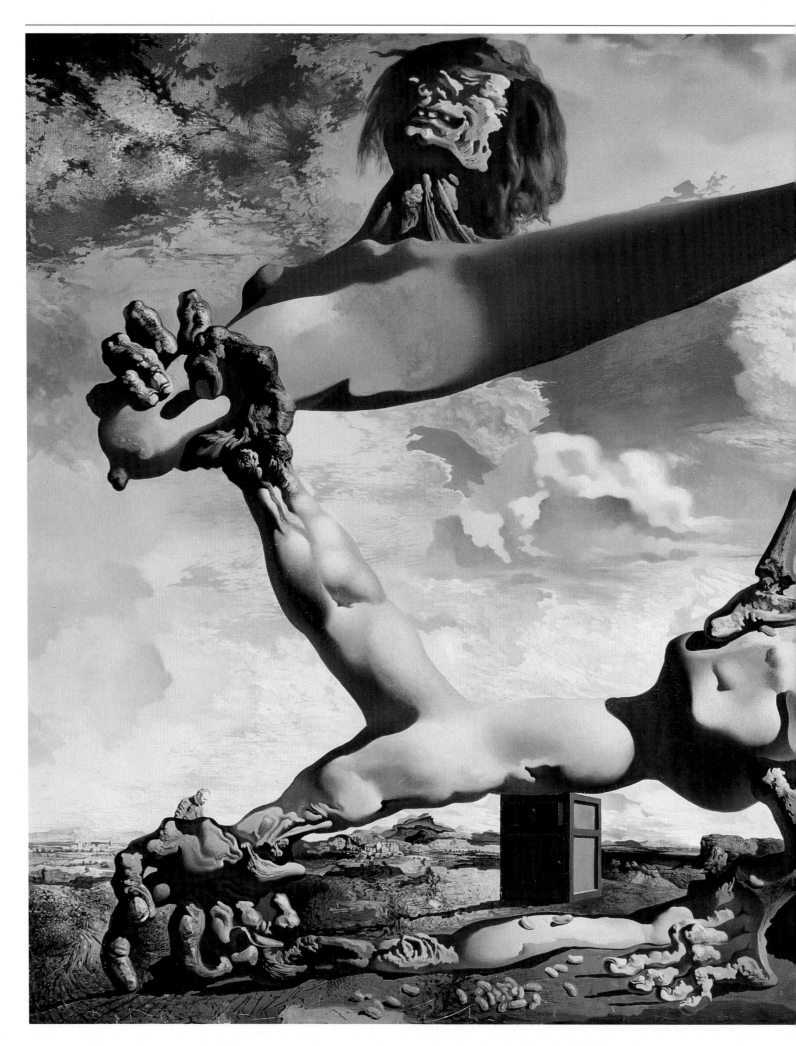

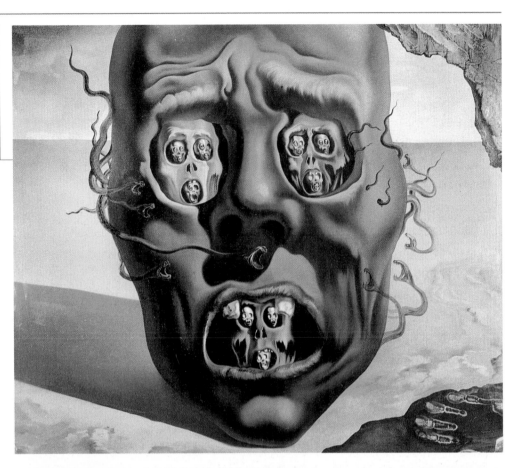

♦ THE FACE OF WAR (1940-41, Rotterdam, Boymans-van Beuningen Museum). The canvas recalls the horrors of war described by the Spanish painter Goya, but as always in Dalí the planes of reality are multiplied. Here, like Chinese boxes, each skull contain another, *ad infinitum*. A macabre note is added by the frowning forehead and by the snakes, which highlight the spectral nature of the scene.

♦ SOFT CONSTRUCTION WITH BOILED BEANS, PREMONITION OF THE CIVIL WAR (1936, Philadelphia, the Philadelphia Museum of Art). The monstrous creature, born of anatomic sections put back together, stands out triumphantly on the canvas and points to the destructive action of war, which dismembers bodies. The aggressive spirit is clear in the knotty hand that squeezes a soft breast, where there is also an erotic allusion. The predestined victims of war are the poor, symbolized here by the boiled beans.

♦ CANNIBALISM IN AUTUMN (1936, London, Tate Gallery). For Dalí, swallowing was a sort of obsession linked to eroticism or – as in this case – to destruction. This fusion of amorphous bodies devouring each other represents the paradox of the internal conflict caused by the Spanish Civil War. Even the landscape in the background takes part in the act of self-destruction.

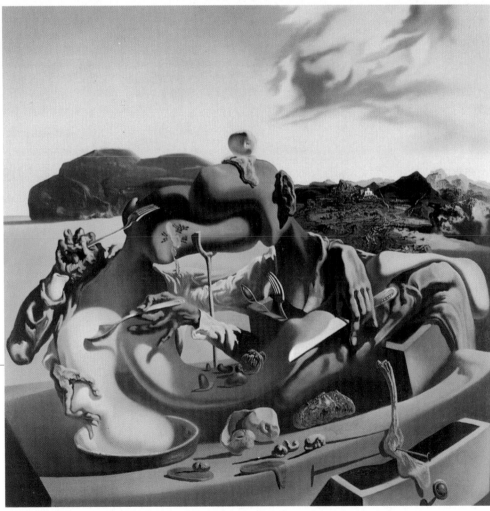

A DESECRATED TRADITION

Right from his early years at the Academy in Madrid, Dalí was convinced that there is no point attempting to develop new artistic techniques, since he believed it was impossible to go beyond the levels achieved by the Renaissance masters and by the photographic detail of the Flemish painters, especially Vermeer. For this reason he concentrated on content, maintaining a meticulous, conventional technique. Faithful to his national pride, he allowed himself to be influenced by Goya and Velázquez, and borrowed El Greco's dramatically elongated, almost threadlike figures.

● The model to which he returned continually during his life was François Millet's *Angelus*, "The only painting in the world that tolerates the immobile presence, the hopeful encounter of two beings in a solitary landscape, crepuscu-

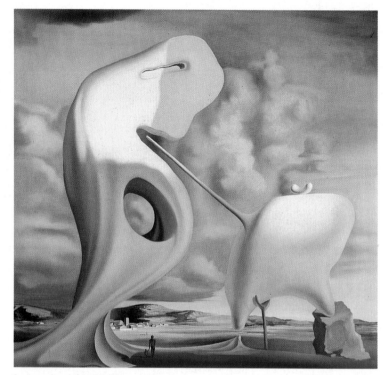

◆ MILLET'S ARCHITECTONIC *ANGELUS* (1933, New York, Pers Gallery). The model of Millet's *Angelus* is transformed into a rock face which repeats the leaning pose of the peasants, yet the lyrical atmosphere of the original remains unaltered.

lar and mortal." The subject was repeated in conjunction with the face of Goya, but the original spirituality was often turned in an erotic direction.

● From the fifties onwards, classical references became more frequent after his religious conversion. In his sacred works tradition became an inescapable term of comparison for the architectonic constructions, the faces and the attributes. Dalí disavowed his previous cynicism and rediscovered a cosmic mysticism.

● While sixteenth-century Mannerism had fed his Surrealist fantasy, Renaissance painting acted as a brake on his imagination. In his late work there are references such as Michelangelo's torsions, the faces of Raphael's Madonnas, and the sharp style of Piero della Francesca. Yet these precedents disintegrate with his new interest in physics. The elements now float freely in space, while the images assume an unexpected balance by means of curious molecular structures.

◆ EXPLOSION OF A RAPHAELESQUE HEAD (1951, private collection). With great creative power, Dalí combines a face taken from Raphael's Madonnas with the outline of the Pantheon; the hybrid obtained is then disintegrated into fragments shaped like rhinoceros horns.

◆ THE MADONNA OF PORT LLIGAT (1935, Tokyo, Minami Museum). Dalí cites Piero della Francesca's *Brera Madonna* in the structure, the sharply-defined style, and the shell with the egg hanging from it, although the whole image seems to be floating.

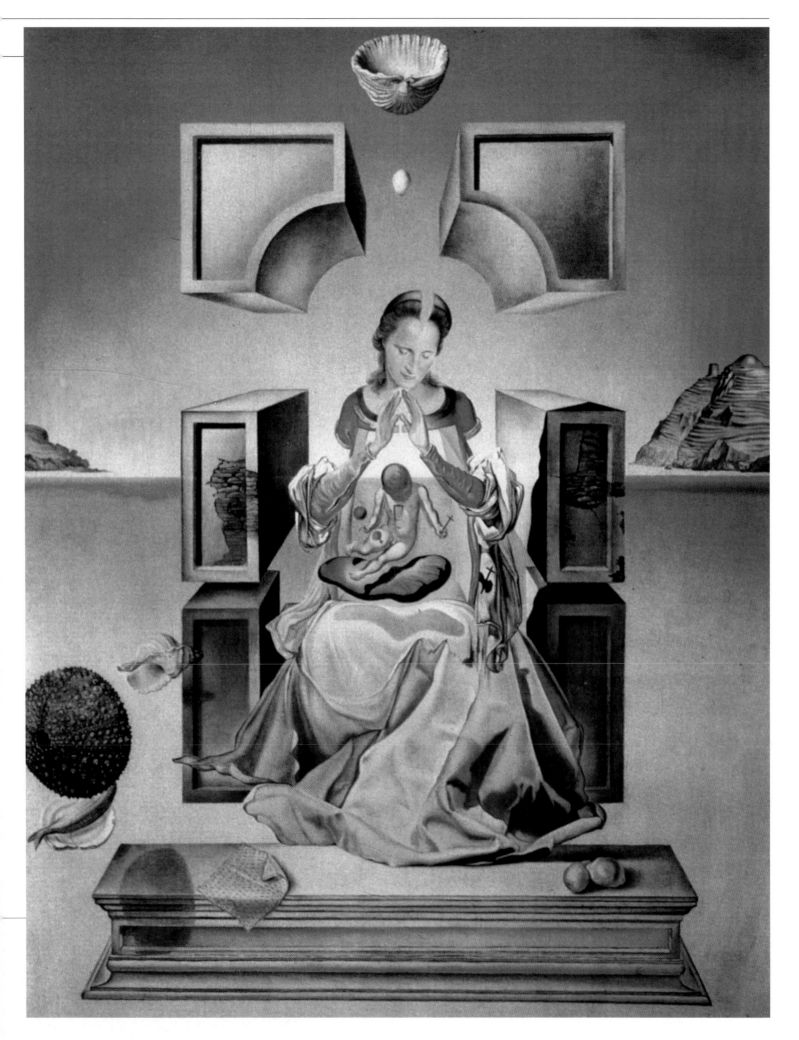

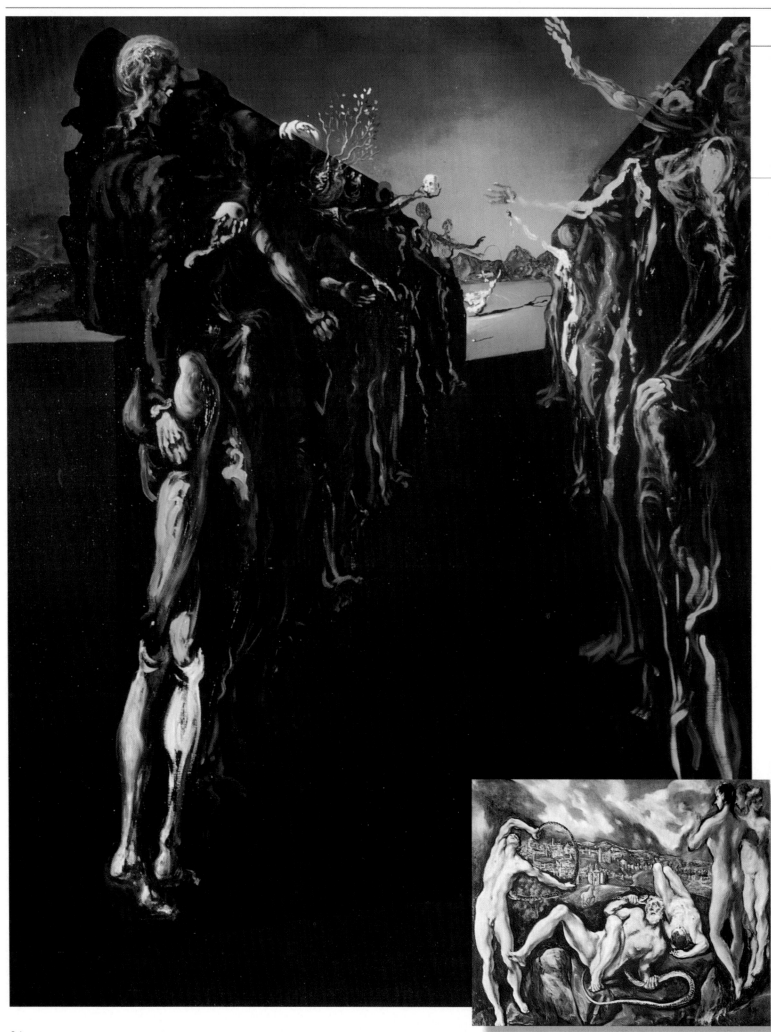

◆ PALLADIO'S THALIA CORRIDOR
(1937, West Dean, Great Britain, Edward James Collection). In a long, spectral corridor, Dalí uses human forms to recreate the perspective of the theater sets produced by the Mannerist architect Palladio in Vicenza (in the Teatro Olimpico, c. 1580). The paranoiac vision of the Spanish artist, who animates still lifes and immobilizes human figures, is also applied to architecture. By means of the play of contrasts, the walls thus become mobile and assume human profiles. The tapered outlines, on the other hand, are influenced by the tormented figures of the Mannerist artist El Greco (below, *Laocoonte*, 1610-14, Washington, National Gallery).

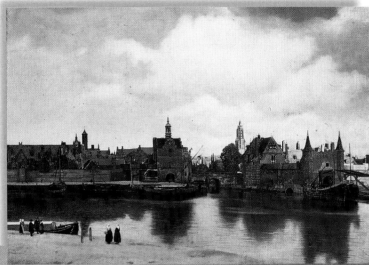

◆ APPARITION OF THE CITY OF DELFT (1935-36, Switzerland, private collection). In the usual sandy setting, Dalí introduces the outline of Delft taken from Jan Vermeer (left, *View of Delft*, The Hague, Mauritshuis, 1661). The visionary aspect is also created by the three evanescent figures in the foreground and by the car flowering on the tree.

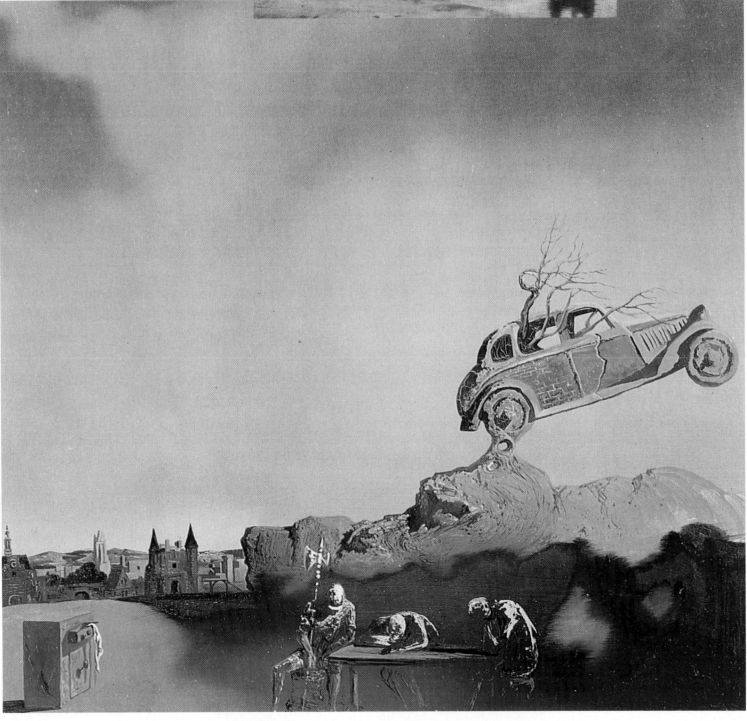

HOMAGE TO THE OBJECT

"All my work is nothing more than a reflection of what I do, write and think." Dalí was a volcano of ideas desperate to take shape: he wrote novels such as *Hidden Faces*, illustrated books such as *The Divine Comedy*, designed clothes and jewelry, produced texts for the theater with Luchino Visconti, for the cinema with Buñuel and Hitchcock, or for Walt Disney's never-released *Destiny*.

● He invented garments with anatomical padding and puzzles like the aphrodisiac dinner jacket, with glasses filled with dead flies hanging from it. On Fifth Avenue in New York he even did window displays with provocative compositions of dummies and bathtubs. His first three-dimensional surreal creations date back to the end of the thirties when, urged on by the English collector Edward James, he produced several curious *assemblages*, highly ironic and meaningless, such as *The Lobster Telephone*.

● In the early 1910s Dalí's friend Duchamp had already produced "ready-mades", whose original purpose he altered through a form of conceptual alienation. Surrealism celebrated everyday objects to the detriment of painting, claiming that anything can become art. Following this principle, Dalí's works are born from the idea that "The Surrealist object exists only for the honor of thought": devoid of practical uses, they assume an almost fetishistic value.

● The continuity Dalí found in nature led him to the idea of identity between the animate and the inanimate: and so he used drawers to annul the immobility of statues such as the *Venus of Milo*. His intention was to use concrete elements to create objects that would materialize wild fantasies, often with sexual overtones. In the seventies Dalí concentrated on sculptures in bronze, repeating the classical themes of his paintings: in the third dimension the opposition between soft and hard in the watches and the combination of human and animal take on the homogeneity of a single material.

♦ RETROSPECTIVE BUST OF A WOMAN (1933, Belgium, private collection). Dalí creates objects that shock the viewer and wake up the unconscious. The ants point to the frenzy that corrodes forms, while the bread and the corn express the charm of the woman, her edible beauty.

♦ VENUS OF MILO WITH DRAWERS (1936, Rotterdam, Boymans-van Beuningen Museum). There are numerous copies, made in the seventies, of the bronze statue mounted in plaster. The presence of the drawers adds a functional purpose to an object of pure esthetic value, and animates the immobile figure.

◆ LOBSTER TELEPHONE
(1936, London,
Tate Gallery).
The Surrealist object
belongs to the tradition
of Duchamp's "ready-
mades", objects taken
from real life and
juxtaposed in an
unusual manner.

◆ FACE OF MAE WEST
(1934-35, Chicago,
The Art Institute of
Chicago). Dalí decorates
a room with the
features of the actress:
her eyes are paintings,
her nose a fireplace,
and her hair a curtain.
The famous lips-sofa
was also produced as
an independent item.

TOWARDS A NEW BALANCE

In 1904, when Salvador Dalí was born in Spain, Matisse was working in Paris on the masterpiece *Luxe calme et volupté*, shown the following year at the first exhibition of the *Fauves* group. In the same year Albert Einstein discovered relativity, which together with Plank's quark theory undermined the foundation of the ideas of Newtonian man, already rendered precarious by the publication of Freud's *The Interpretation of Dreams* in 1900.

● The rebellion of the avant-garde movements was under-

son, despite his anarchic character, he was expelled from the Surrealist movement, which was actively committed to Communism. In 1936, shocked by the outbreak of the Spanish Civil War, he described the drama at the same time as Picasso was immortalizing it in *Guernica*.

● In 1940, the growing tension in Europe convinced Dalí to move to America, where he met up with many of his Surrealist colleagues, from André Breton to Max Ernst. As the Second World War was raging, Dalí's eccentricity made him a well-known figure in New York. Then, shocked by the explosion of the atomic bomb in Japan, he rediscovered religion.

● During the Cold War he concentrated once again on religious

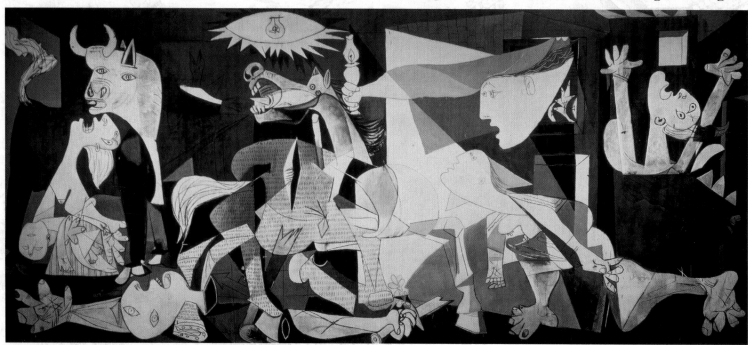

way when the First World War broke out. And it was during the tormented process of post-war reconstruction that Dalí took his first steps as a painter. 1929 was, however, a crucial year in his development, and in that of society in general when the disastrous effects of the Wall Street Crash began to hit Europe: in Paris Dalí joined the Surrealist movement and met his future wife Gala, who would make a decisive contribution to his artistic evolution.

● During the thirties the menacing emergence of Hitler on the European scene was also reflected in Dalí's paintings: he portrayed the dictator as a fragment of a historical situation, though abstaining from any political judgement. For this rea-

themes, took an interest in science, and wrote several books. While he was working on screenplays for Walt Disney and Luchino Visconti and illustrating literary masterpieces, he opposed the spread of the new mass society.

● On his return to Europe he obtained numerous international awards; in the final years of his life, now stricken by illness, he retired from public view. The curtain fell for him in January 1989, when he was buried in the theater-museum in Figueras.

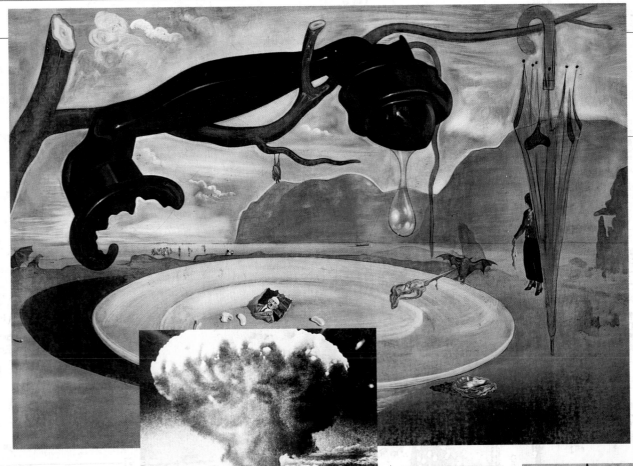

◆THE ENIGMA OF HITLER (c. 1939, Madrid, Centro de Arte Reina Sofia). The telephone pouring sweat and bitten by ferocious words, and the bat-like umbrella refer to the negotiations between Hitler and Chamberlain during the time of crisis. The beans on the plate once again indicate the victims of Hitler, accused by his photo.

◆JOAN MIRÓ *Rhythmic Characters* (1934, Westfalen, Kunstsammlung, Nordrhein). Miró, Dalí's fellow countryman, is well-known for the biomorphic, colorful nature of his Surrealism, which replaces the dream visions of his colleagues with abstraction.

◆ PABLO PICASSO *Guernica* (1937, Madrid, Casón del Buen Ritiro). The bombing of Guernica, which shocked Spain, becomes an apocalyptic vision of the destruction caused by war, a cry of pain the involves the whole world.

◆THE ATOMIC MUSHROOM When the atomic bomb was dropped on Hiroshima and Nagasaki in 1945, the world discovered how precarious its security really was.

◆ MAX ERNST *The Whole City* (1937, Paris, private collection). The spectral landscapes painted by Ernst during these years depict nature devastated by the Second World War, petrified or returned to a primordial state.

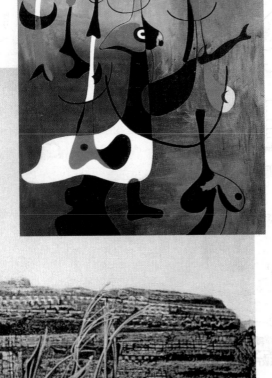

◆ DALÍ THE SUCCESSFUL SCREENPLAY WRITER Dalí was called by Walt Disney (top left) in 1946 to write the screenplay for the film *Destiny*, which was never released. For Luchino Visconti (bottom) he produced the theater scenes for Shakespeare's *As You Like It*.

ART AND CONSUMERISM

Despite his histrionic vocation, Dalí was deeply rooted in his own age, and reflected its fragility, its contradictions, and its obsessions. Like an acrobat without a safety net, he was not afraid of experimenting and provoking if it would make people talk about him, even in scorn. For this reason he has become a model of behavior for a whole range of very different artists. Even now, we can see echoes of his ideas in fields such as advertising and theater set design.

● In the sixties, a period characterized by rebellion and a desire for innovation, Dalí's scandals – sometimes crowned by fines or even fights – paved the way for the *happenings* of the Austrian artist Hermann Nitsch or the Russian Allan Kaprow, for whom art transcends its traditional limits and becomes action, protest, the practical determination of artistic and ideological thought.

● While Dalí's Surrealist cinema seduced Alfred Hitchcock, who asked him to develop the dream sequences for *Spellbound*, the main heir to his work in America was Pop Art, which interpreted the recent consumer society by ma-

nipulating its objects in an unusual way: the creations of Oldenburg, for example, repeat the limp forms and solidified foods of Dalí's paintings in three-dimensional form.

● Andy Warhol, whose character was equally outrageous, was the artist who followed Dalí most closely in making his life a spectacular work in itself. The child of consumerist prosperity, he used the new instruments of advertising and movies to increase his own fame, and like Dalí was ironically but firmly opposed to mass culture. With Dalí and Warhol, kitsch became a means of expression behind which there was often a serious intent: in fact their offensiveness and arrogance served to capture the attention so that they could then deliver a lucid, serious message.

● Dalí's figurative repertoire, which combines nature and artifice, human and animal, sometimes also containing cultural citations, was taken up in Italy by Fabrizio Clerici. His paintings show a similarly Baroque, though less violent style, with which he gives free rein to his imagination and his obsessions.

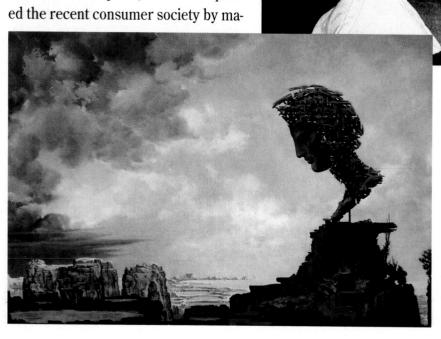

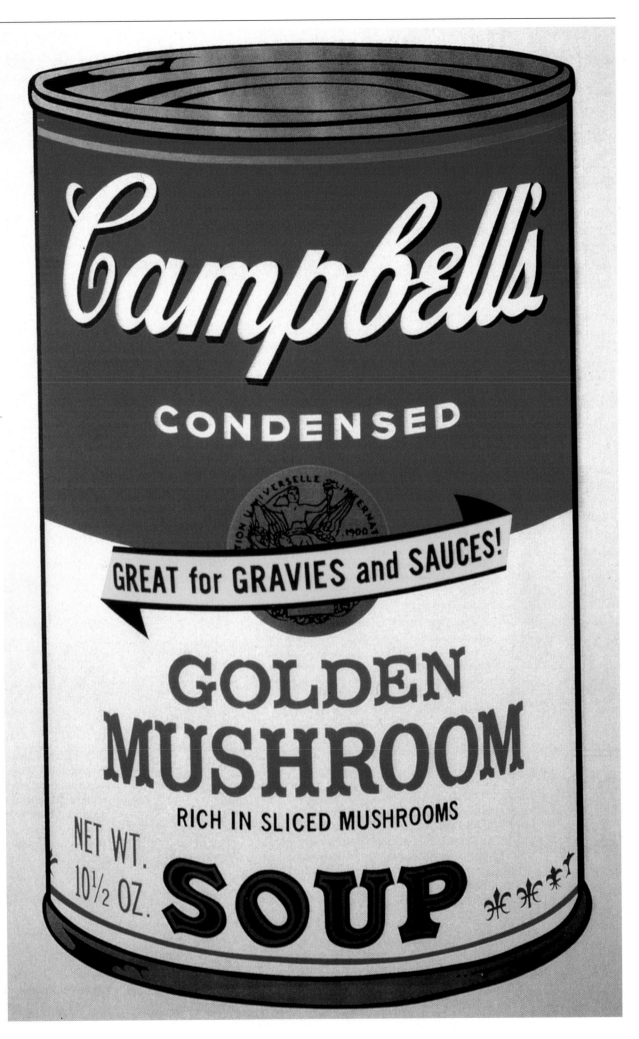

◆ CLAES OLDENBURG
Ghost Typewriter
(1963, New York).
The ghostly, limp
outlines reproduce
the soft forms created
by Dalí. The artist plays
with the contrast
between a surface
thought of as rigid
and its unexpected
softness, which
undermines
its function.

◆ ANDY WARHOL
Campbell's Soup Can
(1969, private
collection). Warhol
becomes a witness
to the consumer society,
and opposes the loss
of originality inherent
in mass-produced
goods. His irony
emerges through the
serialization of images,
or through extravagant
actions reminiscent
of those of Dalí.

◆ CLAES OLDENBURG
Sink
(1966, private
collection).
Oldenburg reproduces
everyday objects
in such a way as to
annul their original
function. Like Dalí,
he juxtaposes liquefied
forms, like the sink,
with rigid forms like
his plastic steaks.

◆ FABRIZIO CLERICI
Minerva Phlegraea
(1956-57, Rome,
private collection).
Clerici reworks
Mannerist and
Surrealist culture,
creating to a dreamlike
world composed of
shadows and surreal
images. Here he
illustrates a scene from
Virgil's *Aeneid*.

THE ARTISTIC JOURNEY

For a vision of the whole of Dalí's production, we propose here a chronological reading of his principal works.

◆ PORTRAIT OF LUIS BUÑUEL (1924)

The work belongs to the phase in which Dalí was influenced by de Chirico and by the "return to order" climate of the post-war years, when avant-garde subversion was replaced by a return to realism. Dalí met his friend Buñuel at the Academy in Madrid; together they would make two films that remain among the masterpieces of avant-garde cinema.

◆ FIGURE AMONG THE ROCKS (1926)

The canvas was produced when Dalí was strongly influenced by his fellow countryman Picasso, whose raw creative power he admired. The figure dominates the surface through its diagonal pose and the plasticity of the forms. The harsh features seem to echo the asperity of the rocks, a reference to the Cadaques landscape.

◆ ILLUMINATED PLEASURES (1929)

The work is a collage, both in terms of technique and of content, in which newspaper cuttings – like the face of the lion – are juxtaposed with citations from other painters. The painting with the cyclists is a tribute to Magritte, while the column in the center is an echo of Max Ernst's birds. The composition contains an erotic allusion in the movement of the cyclists and in the figure hiding.

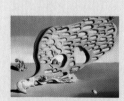

◆ THE ENIGMA OF DESIRE (1929)

The painting is part of a series of canvases in which the protagonists are rocks with rounded outlines, inspired by the jagged coastline of Cadaques. Nature is transfigured by the unconscious, as is shown by the words "my mother" repeated obsessively on an extension of Dalí's face. The ants, the locust and the dagger in the background indicate the corruption of the flesh and death.

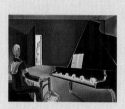

◆ PARTIAL HALLUCINATION: SIX APPARITIONS OF LENIN ON A PIANO (1931)

This work caused Dalí to clash with the Surrealists, who were supporters of Communism. Despite the eccentricity of the themes he chose, such as the paintings devoted to Hitler, Dalí was anarchic by nature. The face of Lenin, repeated in phosphorescent halos, often appeared at around this time. The figure on the left evokes Dalí's father and symbolizes an unconscious childhood punishment.

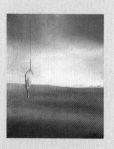

◆ EGGS ON A PLATE WITHOUT THE PLATE (1932)

Like the limp watches, eggs have a temporal and erotic significance and become a recurrent theme in Dalí's work in the thirties. At the same time they are a playful reference to the eggs painted by Velázquez in *The Old Cook*. The background is saturated in Mediterranean light, once again inspired by the landscape of Catalonia.

◆ MEMORY OF THE CHILD-WOMAN (1932)

The setting with the beach in the background and the strange shape in the foreground is once again a reworking of the rocky landscape of Cadaques, which seems in this case to have assumed a feline physiognomy. The glass case with the pocket watches on the right expresses a sort of timelessness: real time in the consciousness is immobile, which is why the woman can be a child at the same time.

◆ GHOST CART (1933)

The canvas is part of a series of works characterized by a lyrical style that contrasts strongly with Dalí's usual provocation. With the techniques learned from Arcimboldo he describes a dual reality, painting a cart driven by two characters who belong figuratively to the city in the background by forming its towers.

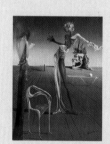

◆ WOMAN WITH HEAD OF ROSES (1935)

Dalí evokes the metaphysics of El Greco, and above all that of De Chirico, in the two tapered figures, reminiscent both of the elongated bodies of the former and the famous dummies of the latter. De Chirico is also cited in the stage setting. The head of the figure in the center, on the other hand, is a tribute to Arcimboldo. The combination of animate and inanimate elements renders the scene surreal.

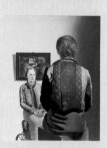

◆ THE *ANGELUS* OF GALA (1935)

Gala, born of Russian parents, was the driving force behind Dalí, though she had already been the muse for other Surrealist artists: when Dalí met her, she was the wife of the poet Paul Eluard and the mistress of the painter Max Ernst. The dual pose of the woman, with her back turned and facing the viewer, serves to create a sense of spatiality: Dalí was to use the device again in the famous portrait in front of the mirror of 1973.

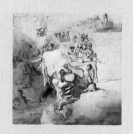

◆ THE GREAT PARANOIAC (1936)

The canvas is a visual *caprice* learned from the fantastic painting of the Mannerists, of Leonardo and Arcimboldo: two faces are recomposed through contorted, ghostly pale figures. Through the title, the work illustrates the paranoiac critical method: beyond the surface, the multiple images possess a second reality that springs from a visual hallucination.

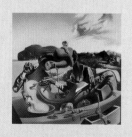

◆ CANNIBALISM IN AUTUMN (1936)

In the background, behind the horrible cannibalism of the forms, we can make out the tragedy of the Spanish Civil War, which shocked Dalí profoundly. Here the civil war is likened to the self-destruction of the body-state: two distinct but indivisible figures are devouring each other. Food is a fundamental element of the painter's obsessions.

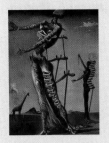

◆ **GIRAFFE ON FIRE (1936)**
The protagonists of the scene are the two female dummies supported by slender crutches and lacerated by drawers (a motif which Dalí, like Freud, related to autoerotism). The most curious subject, destined to remain in the viewer's mind, is the giraffe burning inexplicably in the background. The pose of the two figures is drawn from contemporary fashion magazines, which Dalí sometimes worked for.

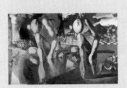

◆ **METAMORPHOSIS OF NARCISSUS (1937)**
This powerful, fascinating work plays on the stereoscopic nature of two forms: the body of the mythological Narcissus, leaning forwards, and the hand on the right holding the narcissus bulb. The warm light of the figure contrasts with the cold light of the hand, which indicates that petrifaction has occurred. Dalí also composed a poem on this theme.

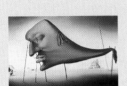

◆ **SLEEP (1937)**
The subject derives from a nightmare experienced by the painter, in which an amorphous, bodiless face appears, held up by strange, fragile crutches. The work reflects the precarious condition of contemporary society, which needs support, but at a subjective level it also points to the state of absolute relaxation and vulnerability typical of the human consciousness during sleep.

◆ **THE INVENTION OF MONSTERS (1938)**
Like a sort of catalogue, the painting repeats all the monsters that appear in Dalí's surreal painting: the burning giraffe, the woman with the face of a horse, the shadows that form zoomorphic shapes, the bleak landscape, the hand with the egg. Seated at the table are Dalí and Gala, whose faces are reproduced and merged into a single hybrid in the stereoscopic reflection on the left.

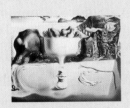

◆ **THE APPARITION OF A FACE AND A FRUIT-BOWL (1938)**
The canvas is a manifesto of the paranoiac critical method and the visual tricks that Dalí often uses. Next to the fruit-bowl and the face it evokes, we can make out a dog that occupies the whole surface of the painting, and several small examples of self-reference that take up the general theme of the composition, creating an obsessive repetition and variation.

◆ **SPAIN (1938)**
The subdued tones give the work a spectral atmosphere. The battle seen in the background is a tribute to Leonardo da Vinci, while the pose of the soldiers echoes the evanescent profile of the woman in the foreground: the allegory of Spain from which the title is drawn. The pairing of Spain and battle scenes reflects the theme of the civil war that was destroying the country.

◆ **SLAVE MARKET WITH THE DISAPPEARING BUST OF VOLTAIRE (1940)**
Gala, the symbol of liberation, appears on the left. In the center is the bust of the philosopher, taken from a sculpture by Houdon. Voltaire represents reason which inhibits the unconscious, expressed by the slaves in the background. Beneath a rocky vault, next to the slaves, are the two woman in Dutch dress who form the features of Voltaire.

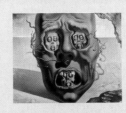

◆ **THE FACE OF WAR (1940-41)**
In a horrific game of Chinese boxes, Dalí depicts a skull whose cavities are filled with smaller skulls, which in turn contain even smaller skulls. The lines on the face make the work even more anguished, together with the subdued tones and the handprint, the last trace of man in the Spanish desert after the civil war.

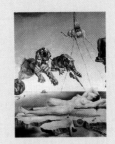

◆ **DREAM PROVOKED BY A BEE AROUND A POMEGRANATE, ONE SECOND BEFORE WAKING (1944)**
The canvas was painted during Dalí's stay in America, when he painted works of a commercial nature. The image, which he termed "a hand-painted color photograph", depicts a nightmare caused by the bee in the foreground: from the pomegranate to the rifle, it marks an obsessive crescendo of aggression.

◆ **PORTRAIT OF MRS. ISABEL STYLER-TAS (1945)**
This work, too, was painted in America, where Dalí concentrated on portraiture. Finely executed, it is structured according to Mannerist models typical of fantastic painting: the female profile is echoed and contorted in the rocky wall on the left. The precision of the features and the pose are reminiscent of the portraits of Piero della Francesca.

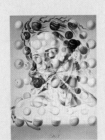

◆ **GALATHEA OF THE SPHERES (1952)**
The work belongs to the time of Dalí's interest in physics, when he disintegrates bodies through a centrifugal movement. Here the bust of his wife disappears as it is shattered into molecules. Numerous similar spheres rotate in the air, recomposing the woman's features, with a *trompe l'oeil* in the Mannerist style. The face is drawn from that of Christ in Leonardo da Vinci's *Last Supper*.

◆ **THE LAST SUPPER (1955)**
This illustration of the episode from the New Testament, like all Dalí's religious works, is of considerable size. The realism of the style contrasts with the surreal artifice of Jesus as he nears death. The painting is based around the number twelve, which determines the architectonic structure as well as the number of figures.

◆ **PORTRAIT OF MY DEAD BROTHER (1963)**
Even in later life, Dalí was obsessed by the specter of his brother. In this painting, the face of the young man – who died at the age of seven but is depicted here with older features – is broken up as in an atomic structure, thus becoming a disturbing apparition. In the background we can make out two peasants executed in the style of Millet.

◆ **GALA OBSERVES THE MEDITERRANEAN WHICH AT A DISTANCE OF TWENTY METERS TURNS INTO THE PORTRAIT OF ABRAHAM LINCOLN (1976)**
Seen from close-up, the image seems to be an abstract composition in which we can only just make out the body of Gala with her backed turned. However, at a distance of several meters we can distinguish the outline of Abraham Lincoln. In this *trompe l'oeil* the woman's hat becomes the man's eyes.

TO KNOW MORE

The following pages contain: some documents useful for understanding different aspects of Dalí's life and work; the fundamental stages in the life of the artist; technical data and the location of the principal works found in this volume; an essential bibliography.

DOCUMENTS AND TESTIMONIES

Dalí on Dalí

"Every morning, when I wake up, I feel a supreme pleasure at being Salvador Dalí, and I ask myself in astonishment what remarkable things this Salvador Dalí might do today."

[*Diary of a Genius*]

"There are two important things that can happen to a contemporary painter:
to be Spanish,
and to be called Gala Salvador Dalí."

[*The Secret Life of Salvador Dalí*]

"Even I, as I paint, do not understand the meaning of my paintings But it does not follow that they have no meaning: in fact their meaning is so profound, complex, coherent and involuntary that it escapes the simple analysis of logical intuition."

[*The Secret Life of Salvador Dalí*]

"The two most powerful driving forces behind the refined artistic brain of Salvador Dalí are first the libido, or the sexual instinct, and second the anguish of death."

[*Diary of a Genius*]

An ironic shyness

"Pure rose that washes away artifices and sketches / and opens the tenuous wings of smiles. / Salvador Dalí of the olive voice! / I say what your character and your paintings tell me."

[Federico Garcia Lorca, *Ode to Salvador Dalí*]

"Do not look at the hourglass with the membranous wings, / nor the hard fossil of allegories, / while your life flowers before the sea, / peopled by boats and sailors."

[Federico Garcia Lorca, *Ode to Salvador Dalí*]

"Despite the fact that he passed through the School of Fine Arts, Dalí gave the deceptive impression that he had only just freed himself from his mother's apron strings. [...] Slim, shy, phlegmatic, well-mannered, he had an inexhaustible eloquence that his natural humor and his Spanish accent tinged with comic effect, but he knew how to keep silent and did so for long spells, curled up in an armchair, attentive and serious. Of prodigious intelligence, he was able to demolish any mental construction: he came out with enormously extravagant absurdities that he alone managed not to laugh at."

[André Thirion, *Révolutionnaires sans révolution]*

A versatile genius

"If Salvador Dalí has turned his attention towards France, it is because he can do so, so that the gifts as a painter with which God has blessed him can have the time to ripen. What does it matter if, to stoke his fire, he makes use of the pencil of Ingres or the wooden shapes of Picasso's Cubist works!".

[Anonymous, in "*D'aci, d'alla*", January 1926]

"Dalí has given Surrealism an instrument of the first order, namely the *paranoiac critical method*, which he has shown himself able to apply to painting, poetry, cinema, the construction of Surrealist objects, fashion, sculpture, the history of art and, if necessary, to any sort of exegesis."

[André Breton]

"I wanted Dalí for the cutting edges of his paintings – very similar, certainly, to those of de Chirico - for his long shadows, the infinite alienation, the receding line, which meets in infinity, the formless faces. Of course he also invented very strange things that could not be realized."

[Alfred Hitchcock]

HIS LIFE IN BRIEF

1904. Salvador Dalí is born in Figueras on 11 May.

1918. Encounters Impressionist painting through the local artist Pitchot, his teacher.

1920. Discovers Italian Futurism through avant-garde journals, and is influenced by the movement.

1921. Enrolls in the Academy in Madrid, from which he will be expelled in 1926 on suspicion of subversive political activity. At the Academy he meets the poet Federico Garcia Lorca and the director Luis Buñuel, who become his best friends. His relationship with Lorca goes beyond friendship and develops into a homosexual bond. Through Lorca, Dalí discovers Surrealist theories.

1922. After his Cubist period, Dalí is influenced by the metaphysical painting of Giorgio de Chirico.

1925. Reads the works of Freud, which are a revelation for him. Holds his first solo exhibition in Barcelona. During a trip to Paris he meets Picasso and gets to know his painting.

1927. Completes national service and produces his first Surrealist painting, entitled *Honey is Sweeter than Blood*.

1929. Moves to Paris and joins the Surrealist movement. With Buñuel he makes the film *Un chien andalou*. Meets Gala Eluard, his future wife, the beginning of a passion that will last a lifetime.

1931-33. With Buñuel makes the film *L'âge d'or*. On the occasion of the first public showing, the audience is scandalized and destroys the works on display in the foyer: some by Dalí and others by Max Ernst, Juan Miró and Man Ray. Paints several works on the subject of William Tell. In 1931, paints *The Persistence of Memory*. Creates his limp forms.

1934. Paints several works in which he repeats the subjects of Hitler, the telephone, and Millet's *Angelus*. Formulates the paranoiac-critical method, which he expounds the following year in *The Conquest of the Irrational*.

1937. Travels to Italy with Gala to see the masterpieces of Baroque and Renaissance art. In Sicily he paints *Impressions of Africa*.

1938. Thanks to the mediation of the collector Edward James and of Stefan Zweig, he manages to meet Freud in London. Freud is supposed to have commented: "I have never met a more perfect example of a Spaniard. What a fanatic!". Dalí, however, confesses that he was struck by Freud's observation: "In classical works I look for the unconscious, in Surrealist works for the conscious".

1939. Decorates a shop-window in New York for Bonwit-Teller. In doing so he breaks it accidentally, and is consequently fined. The episode increases his popularity in America.

1940-48. Lives in America, where he devotes himself to writing scripts for theater and cinema, and also to the design of jewelry and clothes. He paints portraits and writes his autobiography, *The Secret Life of Salvador Dalí*.

1949. Produces his first canvases on religious themes, such as *The Madonna of Port Lligat*.

1951. Illustrates the *Divine Comedy* and paints religious works.

1964. Exhibitions of his work are held all over the world. Dalí works almost exclusively on sculptures. He is awarded the Grand Cross of Queen Isabella of Spain. Publishes the autobiography *Diary of a Genius*.

1973. After three years of restoration work, the old theater destroyed by fire during the Civil War reopens as the Dalí Theater-Museum in Figueras.

1982. Death of his wife Gala. Dalí loses his creative vein and stops painting. He is awarded the title Marquis of Pubol.

1986. Following a fire in the castle at Pubol, he suffers serious burns and is moved to the tower in the Theater-Museum.

1989. Dies on 23 January and is buried in his theater-museum.

WHERE TO SEE DALÍ

The following is a listing of the technical data for the principal works of Dalí that are conserved in public collections. The list of works follows the alphabetical order of the cities in which they are found. The data contain the following elements: title, dating, technique and support, size expressed in centimeters.

BASEL (SWITZERLAND)
Giraffe on Fire, 1936; oil on canvas, 35 x 27; Kunstmuseum Basel.

BERLIN (GERMANY)
Portrait of Mrs. Isabel Styler-Tas, 1945; oil on canvas, 65.5 x 86; Staatliche Museum zu Preussicher Kulturbesitz.

CHICAGO, ILLINOIS (UNITES STATES)
The Invention of Monsters, 1937; oil on panel, 51.2 x 78.5; The Art Institute of Chicago.

COLOGNE (GERMANY)
Perpignan Station, 1965; oil on canvas, 295 x 406; Museum Ludwig.

DUSSELDORF (GERMANY)
Anthropomorphic Wardrobe, 1936; oil on panel, 25.4 x 44.2; Kunstsammlung Nordrhein-Westfalen.

FIGUERAS (SPAIN)
Galarina, 1944-45; oil on canvas, 64.1 x 50.2; Fundacion Gala-Salvador Dalí.

The Bread Basket, 1945; oil on panel, 33 x 38; Fundacion Gala-Salvador Dalí.

Atomic Leda, 1949; oil on canvas, 61.1 x 45.3; Fundacion Gala-Salvador Dalí.

Galathea of the Spheres, 1952; oil on canvas, 64 x 54; Fundacion Gala-Salvador Dalí.

The Pearl, 1981; oil on canvas, 140 x 100; Fundacion Gala-Salvador Dalí.

The Discovery of America by Christopher Columbus, 1958-59; oil on canvas, 410 x 284; Fundacion Gala-Salvador Dalí.

GLASGOW (SCOTLAND)
Christ Upon the Cross, 1951; oil on canvas, 205 x 116; Glasgow Art Gallery.

HANNOVER (GERMANY)
The Nostalgia of the Cannibal, 1932; oil on canvas, 47.2 x 47.4; Kunstmuseum Hannover.

HARTFORD, CONNECTICUT (UNITED STATES)
Apparition of a Face and a Fruit-Bowl on a Beach, 1938; oil on canvas, 114.5 x 143.8; The Wadsworth Atheneum.

LONDON (ENGLAND)
Cannibalism in Autumn, 1936; oil on canvas, 65 x 65.2; Tate Gallery.

Lobster Telephone, 1936; surrealist object, 15 x 17 x 30; Tate Gallery.

Metamorphosis of Narcissus, 1937; oil on canvas, 50.8 x 78.3; Tate Gallery.

MADRID (SPAIN)
Self-Portrait with "Publicitat", 1923; gouache and collage, 104.9 x 74.2; Museo Centro Nacional, Centro de Arte Reina de Sofia.

The Great Masturbator, 1929; oil on canvas, 110 x 150.5; Museo Centro Nacional, Centro de Arte Reina de Sofia.

The Never-Ending Enigma, 1938; oil on canvas, 114.3 x 144; Museo Centro Nacional, Centro de Arte Reina de Sofia.

The Enigma of Hitler, c. 1939; oil on canvas, 51.2 x 79.3; Museo Centro Nacional, Centro de Arte Reina de Sofia.

Dream Provoked by the Flight of a Bee Around a Pomegranate, One Second Before Waking, 1944; oil on canvas, 51 x 40.5; Collecion Thyssen-Bornemisza.

Girl at the Window, 1925; oil on cardboard, 105 x 74.5; Spanish Museum of Contemporary Art.

MUNICH (GERMANY)
The Enigma of Desire, 1929; oil on canvas, 110 x 150.5; Bayerische Staatsgemäldesammlung, Staatsgalerie Moderne Kunst.

Apotheosis of Homer, 1944-45; oil on canvas, 64 x 119; Staatsgalerie Moderne Kunst.

NEW HAVEN, CONNECTICUT (UNITED STATES)
The Ghost Cart, 1933; oil on canvas, 26.7 x 32.4; Yale National Gallery.

NEW YORK (UNITED STATES)
Illuminated Pleasures, 1929; oil and collage on compressed cardboard, 24 x 35; Museum of Modern Art.

The Persistence of Memory, 1931; oil on canvas, 24 x 33; Museum of Modern Art.

Portrait of Gala, 1935; oil on canvas, 32.4 x 26.7; Museum of Modern Art.

Corpus hypercubus, 1954; oil on canvas, 194.5 x 124; Museum of Modern Art.

PARIS (FRANCE)
Partial Hallucination: Six Apparitions of Lenin on a Piano, 1931; oil on canvas, 114 x 146; Centre George Pompidou.

PHILADELPHIA (UNITED STATES)
Soft Construction with Boiled Beans, Premonition of the Civil War, 1936; oil on canvas, 100 x 99; The Philadelphia Museum of Art.

ROTTERDAM (HOLLAND)
Impressions of Africa, 1938; oil on canvas, 91.5 x 117.5; Boymans-van Beuningen Museum.

Spain, 1938; oil on canvas, 91.8 x 60.2; Boymans-van Beuningen Museum.

The Face of War, 1940-41; oil on canvas, 64 x 79; Boymans-van Beuningen Museum.

STOCKHOLM (SWEDEN)
The Enigma of William Tell, 1933; oil on canvas, 201.5 x 346; Moderna Museet

ST. PETERSBURG, FLORIDA (UNITED STATES)
Figure Among the Rocks, 1926; oil on plywood, 27 x 41; Salvador Dalí Museum.

The First Days of Spring, 1929; oil and collage on panel, 50 x 65; Salvador Dalí Museum.

Memory of the Child-Woman, 1932; oil on canvas, 99 x 119.5; Salvador Dalí Museum.

The Ghost of Vermeer Van Delft that Can Serve as a Table, 1934; oil on panel, 18 x 14; Salvador Dalí Museum.

Slave Market with the Disappearing Bust of Voltaire, 1940; oil on canvas, 46.5 x 65.5; Salvador Dalí Museum.

Geopolitical Child Observing the Birth of the New Man, 1943; oil on canvas, 45.5 x 59; Salvador Dalí Museum.

The Disintegration of the Persistence of Memory, 1952-54; oil on canvas, 25 x 33; Salvador Dalí Museum.

The Ecumenical Council, 1960; oil on canvas, 300 x 254; Salvador Dalí Museum.

VENICE (ITALY)
The Birth of Liquid Desires, 1932; oil on canvas, 95 x 112; The Solomon R. Guggenheim Museum.

WASHINGTON (UNITED STATES)
The Last Supper, 1955; oil on canvas, 167 x 268; The National Gallery of Art.

ZURICH (SWITZERLAND)
Woman with Head of Roses, 1935; oil on wood, 35 x 27; Kunsthaus.

BIBLIOGRAPHY

The following list furnishes some guides useful for obtaining the first instruments of orientation and information on the artist.

1962 R. Descharnes, *Salvador Dalí*, Garzanti, Losanna

1965 P. Waldberg, *Chemins du surréalisme*, Köln

1966 A. Breton, *Le surrealisme et la peinture*, Paris

1967 E. Crispolti, *Il Surrealismo*, Fabbri, Milano

1968 J. Thrall Soby, *Salvador Dalí*, Arno Press for Metropolitan Museum of Modern Art, New York

1970 M. A. Reynolds, *A New Introduction to Salvador Dalí*, Reynolds Morse Foundation, Cleveland, Ohio

1972 M. Fagiolo dell'Arco, *Salvador Dalí razionalista arrabbiato*, in "Studi sul Surrealismo", Roma

1974 A. Reynolds Morse, *Salvador Dalí. A Guide to his Works in Public Museums*, The Salvador Dalí Museum, Cleveland, Ohio

1977 R. Gomez de la Serna, *Dalí*, Mondadori, Madrid

1979 C. Maddox, *Salvador Dalí. Eccentricity and Genius*, New York

1980 P. Schwitt, *Salvador Dalí. La rivoluzione paranoico-critica*, Rizzoli, Milano

S. Wilson, *Salvador Dalí*, exhibition catalogue, London

1981 F. Cowles, *Salvador Dalí. Biographie*, München, Langen Müller

E. Crispolti, *Il surrealismo*, Milano

R. Descharnes, *Salvador Dalí*, Paris

M. Sanouillet, R. Lebel, *Dada, Surréalisme*, Paris

1982 D. Ades, *Salvador Dalí*, Thames and Hudson, London

1984 R. Descharnes, *Dalí di Salvador Dalí*, exhibition catalogue, Ferrara

1986 Various authors, *Tra sogno e mito De Chirico e Dalí, due poli del Surrealismo europeo*, Bora, Napoli

1987 F. Passoni, Reynolds Morse, *Dalí nella terza dimensione*, Master Fine Art Gallery, Milano

M. Secrest, *Salvador Dalí. Sein exzentrisches Leben, sein geniales Werk, seine phantastische Welt*, Scherz, Bern, München, Wien

1988 A. M. Dalí, *Noves Imatges de Salvador Dalí*, Columna, Barcelona

A. Sánchez Vidal, *Buñuel, Lorca, Dalí: El enigma sin fin*, Espejo de España, Barcelona

1989 K. Maur, *Salvador Dalí*, catalogue of the exhibition at the Staatsgalerie of Stuttgart and the Kunsthaus of Zurich, Gerd Hatje, Stuttgart

1989 Various authors, *Dalí scultore, Dalí illustratore*, Stratton Foundation for the Cultural Art, Roma

A. Schwarz, *I Surrealisti*, Milano

1994 R. Descharnes, G. Néret, *Salvador Dalí*, Taschen, Köln

1997 E. Swinglehurst, *Salvador Dalí. Esplorando l'irrazionale*, Edicart, Legnano

WRITINGS BY DALÍ

1942 *The Secret Life of Salvador Dalí*, New York

1963 *Le Mythe tragique de l'Angelus de Millet, Interprétation "paranoiaquenitique"*, Paris

1964 *Journal d'un génie,* Paris

1972 *Dalí über Dalí,* Frankfurt-Berlin

1978 R. Santos Torroella, "Salvador Dalí escribe a Federico Garcia Lorca", in *Poesia*, no. 27-28, Madrid

Chagall
The Falling Angel

Dali
The Persistence
of Memory

Kandinsky
The First Abstract
Watercolour Painting

Leonardo
The Last Supper

Manet
Le déjeuner sur l'herbe

Raphael
School of Athens

Rembrandt
Supper at Emmaus

Renoir
Moulin de la Galette

Rubens
Garden of Love

Van Gogh
Starry Night

ONE HUNDRED PAINTINGS:

every one a masterpiece

The Work of Art. Which one would it be?

...It is of the works that everyone of you has in mind that I will speak of in "One Hundred Paintings". Together we will analyse the works with regard to the history, the technique, and the hidden aspects in order to discover all that is required to create a particular painting and to produce an artist in general.

It is a way of coming to understand the sensibility and personality of the creator and the tastes, inclinations and symbolisms of the age. The task of "One Hundred Paintings" will therefore be to uncover, together with you, these meanings, to resurrect them from oblivion or to decipher them if they are not immediately perceivable. A painting by Raffaello and one by Picasso have different codes of reading determined not only by the personality of each of the two artists but also the belonging to a different society that have left their unmistakable mark on the work of art. Both paintings impact our senses with force. Our eyes are blinded by the light, by the colour, by the beauty of style, by the glancing look of a character or by the serenity of all of this as a whole. The mind asks itself about the motivations that have led to the works' execution and it tries to grasp all the meanings or messages that the work of art contains.

"One Hundred Paintings" will become your personal collection. From every painting that we analyse you will discover aspects that you had ignored but that instead complete to make the work of art a masterpiece.

Federico Zeri

Coming next in the series:

Matisse, Magritte, Titian, Degas, Vermeer, Schiele, Klimt, Poussin, Botticelli, Fussli, Munch, Bocklin, Pontormo, Modigliani, Toulouse-Lautrec, Bosch, Watteau, Arcimboldi, Cezanne, Redon